Oladélé Ajiboyé Bamgboyé

Oladélé Ajiboyé Bamgboyé

Writings on Technology and Culture

Edited by Oladélé Ajiboyé Bamgboyé
and Witte de With

Witte de With, center for contemporary art, Rotterdam

Contents

Bartomeu Marí

Oladélé Ajiboyé Bamgboyé

Preface	7
General Artist Statement	13
What is in a Print?	19
Observations on Performative Simulation within African Iron Smelting	55
Unmasking III	70
Biography	78

From the series *Puncture*, 1994
Coll. Solomon R. Guggenheim Museum, New York

Bartomeu Marí

Preface

This publication brings together texts by Oladélé Ajiboyé Bamgboyé, an artist born in 1963 in Odu-Eku, Nigeria, and based since 1996 in London, where he now lives and works. The book appears on the occasion of the monographic exhibition dedicated to his work by Witte de With, center for contemporary art, from April 28 to June 22, 2000. Far from any retrospective desire, this exhibition ranges freely through the most characteristic themes of his activity, bringing them into public view for the first time in all their breadth and complexity. Indeed, after years of participating in numerous group exhibitions and developing specific projects in European and American institutions, what the artist has gathered together here is primarily his photographic work, as well as video installations and the initial traces of his recent preoccupation with the electronic media.

Bamgboyé's photographic work circles around a leitmotiv which he expresses in various forms, through the rituals involved in the maintenance of his own body. Physical self-upkeep and the continuity of identity in the twilight of domestic intimacy situate him in closest relation to subjectivity. The domain of the private, of the condensed and bounded microcosm of the home, is where we as subjects are still free of the rules of social behavior, where the rituals have to do with the internalization of conventions and with their transgression. Sexuality, dreams, rest, health, cleanliness… these seem to guide the artist through the meanders of his own self-rebellion. Using the moving image, in installations or on single-channel tapes, Bamgboyé reaches into the world of his fellows and into the landscape that surrounds him. These works transform, as he proclaims himself in his General Artist's Statement, into emblems of the close link between traditional photographic practices and the push toward the limits of representation, which has deepened into a need to explore both the moving image and narrative. A moving image which is located before and beyond the narratives that cinema has traditionally introduced into artistic practice, and which leads, quite logically, to the use of the electronic media.

Bamgboyé's texts, gathered in this volume, exemplify two essential notions: one is ethical, the other programmatic. Both tend frequently to interweave, shaping the position of the artist not only with respect to the system of art

– the systematic articulation of the grammars of perception and the readings of the world that surrounds us – but also with respect to other types of events, facts that influence the artist's practice and the interpretation of his work. Without any doubt, this ethical position has equally to do with motivations of the artist that go far beyond canonical aesthetics, to probe matters of an anthropological, historical, and social character: the questions of why – and not how – the work comes to be, what is claimed with it, what place it should occupy within the author's poetics?

The programmatic aspect of his writings – the second of the two notions I mentioned – is related to the thematic leaps that have taken place in his work over the last ten years, spanning the shifts in its content and aims. Indeed, the evolutions in the media used correspond to an evolution in the central intention; and this is the rising awareness of the power exerted by the surrounding environment over the conventions of perception, the influence of a technological – or technical – change in the construction of the image of the world that we form as individuals.

The domain of technology here takes on a revelatory role. Although the scientific training of the artist – who initially devoted himself to the study of chemistry before moving into artistic practice and the realm of aesthetic ideas – is necessary to understand the unfolding of his methodology, the anthropological and psychological transformation that his position undergoes is nonetheless undeniable. Where in the photographic work his self-image will be the central theme – proposing a critique of the clichés that surround the perception of the black man's body – the videographic work centers on the proximate other, on the strange but remembered landscape of his native land, and directs itself toward the net of layered intersections that solidifies in our relation to objects. The world in which we have chanced to live frequently sees the fusion of techniques and methods that blur the traditionally accepted modern distinction between original and copy, production and consumption, creation and repetition. Certain results of this fusional process, which we are only now beginning to glimpse, guide us to correlates which are geographic, political, and… psychological. Origin and destiny, where one comes from and where one finds oneself, to what community we claim to belong and with whom we relate, now appear in a highly diluted manner.

Finally, the imperative to reread the consequences of a hypermodernity that has begun to level the world and rasp away its differences, while coloring

them with new hues of personality, leads to an attempt to redesign the tools with which we understand the domestic geography of the immediate environment and the faraway, hostile zones. The various diasporas to which the close of the twentieth century has given rise bring us closer to new maps of the here and now. The way in which the processes of political decolonization correspond to new forms of economic or cultural colonization has as much to do with the remote and the exotic as with the familiar and the nearby.

The strangeness of the self and the familiarity of the foreign are condensed in Bamgboyé's work. May the following pages serve as an opportunity to elevate the contents of this art and all its consequences beyond the dominion of the aesthetic and the close-cropped borders of the image. Within a tradition which begins with modernity itself and which situates the artist as a thinker of the present, Bamgboyé writes and represents on the basis of a hybrid condition of displacement, which problematizes the possibility of return – and its necessity.

From the series "...*Arise*...", 1991

From the series "…*Arise*…", 1991

Oladélé Ajiboyé Bamgboyé

General Artist Statement

Central to my academic interests, teaching philosophy, and artistic-critical framework is the need to make sense of culture and its complexities during the purported era of globalization. Equally necessary for my practice is a critical appraisal of technology as a culture that saturates our world, leading to its ascendance as the dominant discourse in politics, medicine, the media, religion, everyday life, and increasingly, art.

My work has encompassed lens-based media such as photography, video, film, since the mid-eighties in combination with installation and digital media, since the mid-nineties, in a multimedia, communications-oriented art practice of international standing. I am interested in the possibilities for a critical art practice that is informed by the analysis of our cultural condition while avoiding the pitfalls of hypercynicism that can confine us within a framework that longs for an old reality, that binds us to the limiting opposition between representative order and absolute indetermination.

Digital imaging has finally been able to free photo-media practice from the copy and model bind that has defined and confined its possibilities since the invention of photography, allowing photo-based imaging to finally shed its relationship to the object being photographed, ultimately reinforcing its masked difference, and not the manifest resemblance to that object. The current proliferation of multi-paneled video projections within the gallery and museum can arguably be attributed, to the conceptual and aesthetic advances that were made within photo-based practices, especially in the mid eighties. It is therefore no surprise to find that many artists on the cutting edge have incorporated the "photographic" into their practice, be it installation, video, or mixed media, while the impact of digital imaging within contemporary art practice has been influenced by photographic discourse.

Contemporary photo-based media art practice has ultimately paved the way for the discourse of a contemporary aesthetics and perhaps challenges all contemporary image makers to explore the possibilities and challenges thrown up by late capitalism and globalization. The work *Homeward: Bound 1995-97*, considered the issues of hybridity and existence between spaces through the reduction of the journey through the contemporary African

urban cityscape as fleeting collisions of vector forms, a metaphor for the impossibility of translation and the inherent problematic of the cultural encounter. *Homeward: Bound* aimed at avoiding the pitfalls of essentialism and romanticization that can plague the "return" to an original experience by disputing the very existence and validity of that experience.

The work further demonstrates my interest in fleshing out of the complexities that are inherent in the postcolonial reinvention of the globalist, hybrid artist-subject that is reminiscent of the Kantian *Weltbürger*. In particular, I believe that it is important to resolve the increasingly obvious inadequacies of the theories of 1968 that stress the necessity to read all aspects of cultural consumption in reverse as acts of resistance, allowing for the possibility of critical appraisal of market forces that does not imply the embracing of those forces. However, rather than blindly advocating a globalist utopian electronic, networked and market-oriented cultural haven, it is necessary to realize the pitfalls that are present within the application of the so-called post-Berlin Wall theories within contemporary media art.

The necessity of living with and through the new communications technologies that emphasize multimedia content delivery is clear. However, it is also important to realize that the new technologies such as the new electronic commerce (e-commerce) and globalization have simply altered the spatial correlates of centrality, not eradicated it. A pertinent dilemma within critical visual theory centers on how best to deal with overload, fragmentation, and the problematic of identity and representation within our networked, information-driven milieu.

The aforementioned issues were the critical frameworks for the production of the project *The Unmasking, part 2*, which was the result of a two-month research during my residency at ArtPace, San Antonio, Texas, in 1999. *Unmasking* explored the possibility of surpassing the aesthetic bind imposed by the copy and model world of representation and objective (re)production, in a strategy of challenging the postmodern apocalypse of hyper-reality. An important aim of the project remains that of portability, with a view to ultimately developing a mobile 3D Object Digitizing Service (ODS).

The abstraction of a real object from life into mathematical syntax is common within computer programming language and digital simulation. Future developments of the ODS, as the result of working with programmers and 3D specialists, will enable the delivery of fully customized object-variants based on the more famous examples that lie frozen and dormant in the

increasingly complex protection of the major museums, in the guise of Virtual Tours that may actually eliminate the need for an object in the first place.

When the participants in the project are further empowered through the possibility of being able to manipulate an object that many of them may never have access to, in real-time, with the possibility of customizing its appearance, it is the authority to maintain sole access of the object by any one entity that is being challenged rather than the commodification of a rare objet d'art. *Unmasking Workstation* the computer installation presented as part of *Laboratorium* questioned the simultaneous denial of the sophisticated technology that fashioned the production of well-known African artifacts, while appraising their aesthetic prowess.

March, 2000

From the series *Defining Self-Sufficiency*, 1991-94

From the series *Defining Self-Sufficiency*, 1991-94

From the series *Defining Self-Sufficiency*, 1991-94

Oladélé Ajiboyé Bamgboyé

What is in a Print?*

Introduction

When Hal Foster cites the famous query of Paul Gauguin, "Where do we come from? Who are we? Where are we going?"[1] he thus raises the quintessential question of modernity – that of identity. High modernism appealed to alterity, either through the unconscious or the cultural Other, with problematic results leaving many unanswered questions that the subsequent postmodernist and postcolonialist discourse failed to resolve. One such remnant is the profusion of primitivisms supported by a psychoanalytical framework, which has been dominant in art practice since the modernist era.

This essay traces the deployment of "primitivism" within seminal but problematic exhibitions such as the Museum of Modern Art's (MoMA's) modernist spectacle *"Primitivism" in 20th Century Art* (1984) and the subsequent postmodernist exotic spectacle *Magiciens de la Terre* (Centre Georges Pompidou, 1989). The aim of this essay is to outline how current critical discourse has failed to address the problems of visibility of the Other and the problematic of self-othering that continue to plague so-called "inclusive" exhibitions, and to propose an alternative way of acknowledging inclusion without resorting to ideological patronage.

The Problematic of a Suitable Analytical Framework

The sociopolitical, cultural, and theoretical complexities of the now are such that the so-called postcolonial debates in the Western context remain fixated on notions of cultural difference, or ethnicity. The political imbalance that continues to exist between the West and its cultural Others is simply

*1998 MA Report – Slade College of Fine Art. I would like to thank my supervisor, Jean Fisher and also Dr. Michael Newman for his critical feedback on a draft version of this essay.

1. Hal Foster, "Whatever Happened to Postmodernism?" in *The Return of the Real: the Avant-garde at the End of the Century* (Cambridge Mass. and London: October/MIT, 1996), p. 208.

not taken into account within the conception of mainstream exhibitions. Furthermore, there exist apparent inadequacies within postcolonial discourses, with respect to a lack of political agency. As a consequence, the development of art into the spaces normally occupied by anthropology has been made possible through the widespread adoption of the postcolonial discourse developed through the work of Edward Said, Gayatri Spivak, and Homi Bhabba, to name a few.

Within the field of the arts this has resulted in the adoption of the Bhabbaian notion of hybridity that is often expressed as a "reversal of colonial domination and a subversion of the logic of its suppression."[2] By constructing identities that are often highly problematic with respect to a purported totalizing colonial authority, it is considered possible to destabilize the system through its adoption. There are, however, several problems with such a framework that presumes cultural traditions to be stagnant, and somewhat pure, uncontaminated from external effects as discussed below.

Moreover, Peter Hitchcock recognized, through the analysis of Robert Young, major flaws with Bhabba's formulation of the hybrid. This can arise since the very notion of hybridity itself must assume the "articulation of two [or more] undifferentiated knowledges – implying a pure origination of both Western and native cultures."[3] More worryingly, there exists dangers of aestheticizing, or indeed fetishizing of the signs of hybridity and spaces of the "in-between cultures." It is also important to take into account the emergence of parallel discourses globally and more significantly outside the Western metropolitan centers that transcend the narrow-mindedness of regionalism and are a testament to the very dynamic nature of culture.[4] Furthermore, it is now questionable if the model of hybridity is applicable to artistic productions within the purported era of globalization.

In view of the foregoing, this essay will adopt the following analytical frameworks. The first relies on the model of *Nachträglichkeit* that Hal Foster has

2. Homi Bhabba, "Signs Taken for Wonders: Questions of Ambivalence and Authority under a Tree Outside Delhi, May 1817," in *Critical Enquiry* 12:1, 1985, p. 156. Cf. Peter Hitchcock, "The Othering of Cultural Studies," *Third Text* 25, p. 13.

3. Robert Young, *White Mythologies: Writing, History, and the West* (London: Routledge, 1990), p. 150. Cf. Hitchcock, p. 13. Further critique of Bhabba has been postulated by Benita Parry, see Benita Parry, "Signs of Our Times," in *Third Text* 28/29, Autumn/Winter 1994, pp. 5-24.

4. See Geeta Kapur, interviewed by Universes in Universe, at <www.kulturbox.de/univers/doc/opinion/e_kapur.htm>.

borrowed from Freud, in order to analyze the artistic strategies that are being adopted by contemporary artists[5] and the historicities that underpin them. An appreciation of Tsenay Serequeberhan's critical-negative project of the critique of Eurocentrism[6] (in order to deconstruct aspects of relating to the centers of powers, as they relate to the situation of the diaspora in particular) is then employed. The philosophical stance of responding to the Levinassian Other is finally brought to bear, as I will conclude that if the Other cannot be assimilated by the Same, then it is important to let the Other be who they are. The application of this aspect of Levinas's thinking is a radical departure from frameworks that attempt to comprehend the Other and develop an ineffective sympathetical argument within Westernized thought.

This approach is fraught with many pitfalls, as the discussions of the problems with the multinational and global exhibition will show. What needs to happen is for the Other to be recognized for what he/she is, and for the West to refrain from attempting to assimilate their art in order to bolster inadequacies that arise out of historical crises within the Western canon. In this way I hope to develop an appropriate framework of unraveling some of the complexities of negotiating alterity at this fin de siècle that are more sympathetic to the nature of contemporary art practice. Franz West and Yinka Shonibare are both concerned with unanswered questions from the modernist era concerning the materiality of the Other and the failure of postmodernist and postcolonial discourse to deal with those remnants – the most pertinent being the profusion of primitivisms that is fortified within a psychoanalytical framework. The dynamic overlapping of the modernist and postmodernist, postcolonialist concerns for them is the contemporary reality.

This essay examines some of those unanswered questions and how the ever-complex power relationships between artist-curator-institution are negotiated or incorporated into the practice of artists who are working with the limits of the transculturated or hybrid object-materials in a globalist driven conceptual framework. What are the problematics of assuming such an artistic position? What are the dangers of assuming and promoting hyb-

5. See Hal Foster, "The Artist as Ethnographer" in *The Return of the Real*, pp. 171-204.
6. Tsenay Serequeberhan, "The Critique of Eurocentrism," in Emmanuel Chikwudi Eze (ed.), *Postcolonial African Philosophy: a critical reader* (Cambridge Mass./Oxford: Blackwell Publishers, 1997), p. 148.

ridity within a quasi-anthropological curatorial framework? Finally, how are models of multiplicity of centers and transculturated objects deployed within recent postcolonialist exhibitions such as the seminal *Les Magiciens de la Terre*[7] and its subsequent variants up till the second Johannesburg Biennale (Johannesburg and Cape Town, 1997) and the tenth documenta of Kassel.

The pitfalls of *Magiciens* cannot be understood without discussing the issues that informed its conception as a postmodernist reaction to the modernist strategies of MoMA's *"Primitivism" in 20th Century Art*. In turn, it becomes necessary to analyze the problematic residues of "primitivism" within art, and how these issues relate to the work of Franz West and Yinka Shonibare. There appear to be two varieties of "primitivism" within art practices after the 1940s. One is the parody of primitivisms and reversals of ethnographic roles that are more concerned with elements within a specific culture at a particular juncture, as is apparent in the reconstructions of Yinka Shonibare, a self-professed "proper primitivist" in the mold of Jimmie Durham. Such a stance is also inherent to a lesser degree in self-othering stances of Sir Eduardo Paolozzi and Susan Hiller.

The second mode of primitivisms are those which are inherent in the archaic ritualisms of performance artists such as Marina Abramovich, Carolee Schneemann, Franz West, and fellow Austrians Hermann Nitsch and Susan Wenger. Such primitivisms, with the exception of Wenger,[8] are arguably more related to the primitive aspects of the artist's own psychology rather than being connected to the generic child or aspects from tribal society.

The Colonialist Influences on Primitivism in Art

It was during the late Victorian era of empiricism that the museum was established. Furthermore, Coombes astutely reminds us that the "'visibility' of

7. *Magiciens de la Terre* was shown at both the Centre Georges Pompidou and the Grand Hall-La Villette from 18 May-14 August 1989. The premise was to present the first truly international show that presents all works on an equal footing, based on the aesthetic vision of its creator Jean-Hubert Martin.

8. Susan Wenger was an Austrian artist who made the unprecedented move to live with the tribal practitioners of the Yoruba in Nigeria, where she was fully accepted and integrated into that culture, being adorned with special rights to participate in archaic rituals. On Wenger, see Wolfgang Denk, "Noch Eine Andere Reise," in *Die Andere Reise/The Other Journey: Afrika und die Diaspora* (Krems: Kunst.Halle.Krems, 1996), pp. 43-61.

the museum of today owes less to a legacy of Victorian empiricism, than to the continuing hegemony of the presumption of modernist universalism in most national collections. For the most part, then, the museum's 'visibility' reaffirms and naturalizes the apparently immanent meaning of the cultural object."[9] This is why the museum's ideology that everyone is playing on a level field is able to hide the problems of visibility for the Other. Anthropology, as we have seen from Foster in *The Return of the Real*, has a major say in this construction. The discipline of anthropology itself became more professional, with many anthropologists balancing the role of the professional scientific academic with the enthusiasm of the amateur. Anthropologists were exposed to the public mainly through their work with the ethnographic displays at exhibitions during this period. Annie Coombes has demonstrated in *Reinventing Africa* that the anthropologist frequently swayed public opinion through what she termed as the capacity that resulted in the "scientific racism of the predominantly evolutionary narratives."[10]

Many of the early exhibitions represented spectacles of the Empire. Cultural characteristics that were deemed true and uniform for any given race in the spirit of the ethics of the Enlightenment were emphasized. The fact that the often heterogeneous nature of, for example, the indigenous British population of Africans was ignored for the construction of a grand narrative of racial homogeneity becomes important. On the one hand, many Africans were being assimilated (willingly or not) into the dominant culture, while on the other a different, conflicting imagery of their origins was being promoted.

Colonialism lies at the heart of many theories surrounding the notion of "primitivism" within modern art. Many cultures were fixated through their "discoveries" by the West within a system of unequal power relations that continue till today. The primitives – and by this definition I refer to that normally used in anthropological terms to denote someone defined in somewhat negative terms as lacking in organization, refinement, or technological achievement – were geographically ascribed to the regions of Central and Southern Africa, Oceania, and the Americas. As many cultures

9. Annie E. Coombes, "Epilogue: Inventing the Post-Colonial," in *Reinventing Africa: Museums, Material Culture, and Popular Imagination in Late Victorian and Edwardian England* (New Haven and London: Yale University Press, 1994), p. 218.
10. Coombes, "Conclusion," p. 215.

adopted Western modes, their own cultural practices declined, some to the point of extinction. The result was then one of justifying the removal of "authentic" tribal objects by many collectors to the West.

This resulted in the development of the ethnographic collections that functioned as the promotion of the Western ethics of classification and preservation of singular objects. This was done even though it was often in opposition to the practices of those cultures from which the objects were taken. Very often the West compared these external primitives with its own primitives – peasants, children, and the insane, who, like the external primitives had to be controlled. Representations of the colonial subjects were then devised by the West solely for Western consumption that took the form of stereotyping, thereby filling the needs of the Western hegemonies of power.

It was thought, through ethnology, that the arts of all primitives were alike, and therefore inferior to those of the "normal" European. Specifically, the term primitivism has special connotations within modern art. Artistic ideas resulting from the reactions of artists in relating to the conventional societal definitions of the primitive can be found sporadically from Symbolism and Art Nouveau in the 1890s through to American Abstract Expressionism in the 1940s. Yet the strategy of primitivism can often surpass that of simplistic appropriation of exotic extra-European cultural ideals, on which much has been elaborated elsewhere.[11]

What is of interest here is not the tired old argument of the whether the primitive influence in primitivism preceded the birth of modernism, or whether it ingressed afterwards as a silent witness. Rather it is how contemporary artists such as West and Shonibare are able to profit from the institution of art's defense of the purportedly "negligent" effect of such forms within the development of modern Euro-American art. The modernist interest in "primitive art" culminated from unresolved issues with regard to modernist painting. Any mainstream review of modernist art since Cubism demonstrates clearly the formalist struggles within the Western canon in rectifying the objective and (abstractive) nature of African art in particular, in opposition to the pictorial, subjective, and narcissistic nature of mainstream Western art in the same period.

It is common within art history to define the primitive as those who are intent on breaking with a certain tradition in order to forge the foundation for a

11. See Colin Rhodes, *Primitivism and Modern Art* (London: Thames and Hudson, 1994).

new one. The anthropological term usually refers to the "tribal," who are more commonly referred to as savage. The French anthropologist Claude Levi-Strauss coined the idea of the savage mind, which can be thought of as coexisting with the normal Western man, although traces of madness still differentiate him from his Western counterpart. If the dominant society was promoting the primitive as inferior, then the primitivist took a stance against that by challenging or subverting the dominant culture, or aspects of it. This practice, most evident in Surrealism, continues to find favor with many artists who attempt to continue this tradition by trying to eradicate the negative associations that the notion of the "primitive" has within contemporary society. These artists often adopt a quasi-anthropological approach that is the result of the legacy of the theories of "new anthropology" that were born out of the milieu of Surrealism.[12]

The very idea of connecting the notions of primitivism with modern art was outlined in the seminal work *Primitivism in Modern Painting* in 1938. Between 1977-82 the Centre Georges Pompidou exhibited "tribal" objects from the Musée de l'Homme in the vicinity of their modern collection.[13] It seems therefore at this point, that the ideas formed by Goldwater's book of an "affinity" between the primitive and the modern were already being explored. Many of the moderns, like Picasso, Braque, Ernst, and Brancusi, "discovered" African art through the ethnological museums. Their attraction to the alternative aesthetic is perhaps understandable, and this in turn made the African works "contemporary." Many artists were also collectors of this "primitive" art, and attempted to consume this alternative aesthetic, arguably without attempting to understand it.

As a result of the crises in the modernist canon at that time, many artists were able to utilize this new found aesthetic in order to form "new" ways of looking at the objet d'art. The period saw many "new" styles, like the "new" sculptures of Brancusi, and most pertinently, the production of Picasso's *Demoiselles d'Avignon* (1907). Many artists openly demonstrated the influence of African art and the "primitive," and this had several important consequences for the status of African art. Even while it was being defined as "primitive" by the art academy and the museums, African art was being

12. Ibid., "Epilogue: Primitivism and the Dilemma of Post-Colonialism," p. 196.
13. See Thomas McEvilley, "Doctor, Lawyer, Indian Chief, *"Primitivism" in Twentieth Century Art* at the Museum of Modern Art," in *Art and Otherness: Crisis in Cultural Identity* (New York, McPherson, 1992), p. 28.

openly appreciated by the vanguard artists of the time, for its alternative aesthetics that appeared to parallel those of the modernist movement. It seemed that it would finally be better understood. However, as Figueroa pointed out, "it didn't matter how respectful this attitude of the European artists would try to be, it was unfailingly parasitic, and condemned African art to passivity."[14]

Much has been said about the overt parasitism and the reasons for it, which Figueroa refutes. However it would not be unreasonable to suppose that many artists simply used the prevalent parasitic impulse that was conditioned by the imperialist psychology of modern Europe as a strategy to promote their work. This is simply because the primitivist, then and now, is always driven to look outside the dominant culture for inspiration, without ever developing the anthropological obsession with categorizing other belief systems. Artists in general continue to be the eternal scavengers of ideas, where and whenever possible and convenient.

In this respect, Brancusi initially admitted the influence of African forms in his work that led to his "new sculptures" during the early stages of his career. This influence was denied some twenty years later in a popular review of his work,[15] at a stage when the associations of the "primitive" with the artist would perhaps be detrimental to his career. The review sought to define an "affinity" between the "tribal" African forms and Romanian folk art, in the attempt of claiming that the only influences on Brancusi were Romanian and not African. The intent was thereby to reaffirm the art of Brancusi as authentically Romanian.

MoMA's *"Primitivism"* and *Magiciens*

The deployment of the ideas of "primitivism" in modern art is best illustrated in the relationship between MoMA's *"Primitivism"* and *Magiciens*. MoMA's *"Primitivism"* sought to maintain the hegemony of the modernist ideal through a problematic "affinity" between the so-called "tribal" (as if all na-

14. Eugenio Valdés Figueroa, "Africa: Art and Hunger. A Critique of the Myth of Authenticity," in *Third Text* 31, Summer 1995, p. 3.
15. Edith Balasz, "The Myth of African Negro Art in Brancusi's Sculpture," *Revue roumaine d'histoire de l'art* 14, 1977, pp. 107-124. Cited in William Rubin (ed.), "Modernist Primitivism," *"Primitivism" in Twentieth Century Art: Affinity of the Tribal and the Modern* (New York: Museum of Modern Art, 1984), p. 346.

tions do not have tribes in any case) and the modern. This led to the complete formalist decontextualization of the "tribal" works (as no chronological information was given); thereby reducing them to passivity by denying them any history except that of being subservient to the "witnessing" of European modernism. *Magiciens* would change all that. Fifty named artists from the so-called "periphery" would be grouped democratically with their Western counterparts in what was to become a problematic but highly influential exhibition.

The juxtaposition of the huge earthwork by Richard Long with the ground painting form the aboriginal community in Australia is one of the most interesting aspects revealing the motives behind the show. On the face of it, the combination of the two works does express the intended equality in presentation of the non-Western and Western works. However, consider what would have happened had the Richard Long piece been displayed not so dominantly on the wall, but on the ground alongside its aboriginal "counterpart." This is valid, since the majority of Long's works are usually seen along the floor, so why display it so prominently that it seemed to dwarf the aboriginal painting below? The apparent claims of the "silenced" aboriginals "manipulating Western ideas about art"[16] as a way of reaffirming their culture is subverted in the ideological subordination of their work.

The *"Primitivism"* show sought to display in modernist fashion that value judgments are universal, and beyond subjectivity. The *Magiciens* show instead relied on the subjective judgment of its curator Jean-Hubert Martin, thereby demonstrating that value judgments are subject to economic, gender, racial, and social conditioning. What the show erred most on was the naïve treatment of transnational exhibitions as a Benetton new world of art, where no attempt was made to understand the cultural and political conditions that bear upon the work of artists from the "periphery."

While the *"Primitivism"* show attempted to exhibit "seminal" pieces from the "periphery," *Magiciens* simply showed what its curator considered to be aesthetically pleasing, in effect nullifying any critical virtue that the works may have had. There was a chance to show works that represent the crossing over of Western and non-Western ideas, yet these were shunned; more worryingly, there were no African-American artists represented, as it

16. Rhodes, "Epilogue: Primitivism and the Dilemma of Post-Colonialism," in *Primitivism and Modern Art* (London: Thames and Hudson, 1994), p. 202.

seemed the organizers were in search of the "authentic" cultural Other. What the show did represent though, was the first truly ambitious "postcolonial" attempt at exhibition curating that "both interpreted a trend and institutionally established it."[17]

There have been accusations from Cesare Poppi[18] concerning the method of dealing with the classical issue of anonymity within the classification of non-Western art. The main problem centered around the crediting of the work *Façade Painting for Men's House* (region of Maprik, East Sepik Province, New Guinea, 1988) to an artist named as Nera Jambruk. In an attempt to undermine the purported naïve usage of the postmodernist metaphors of "plurality" and "locality," Poppi worryingly slips into the very rhetoric of the concept of subjective reason running from Descartes, Kant, Locke, Hegel to Marx that he sought to dismiss. In traditional fashion, Poppi turned to anthropological "truth" from Donald Tuzin[19] that "proves" that the artists of the region are more akin to community project leaders than individual artists.

Once again, to gain a truthful insight into other cultures, we may always rely on the unfailing accuracy of anthropology. In much the same way, for all his astute criticism of the *"Primitivism"* show, Thomas McEvilley adopts the languages of anthropology by refuting on pure anthropological grounds Rubin's assertion that the "tribal" craftsmen possessed "esthetic problem solving ambitions comparable to those of Modernists." The numerical example cited from an anthropological field study of mathematical errors being copied by school children from their teacher in a remote native school was (4+1=7, 3-5=6, 2+5=9).[20] However what we can learn from this error could also be more about the dangers of adhering rigidly to alien thought systems of beliefs rather than any lack of intellect on the part of "tribals." Using the "error" of one individual as a way of describing the capabilities of a whole tribe is called institutional stereotyping, and is unacceptable. What is important to bear in mind from the two examples are the

17. Cesare Poppi, "From the Surburbs of the Global Village: Afterthoughts on *Magiciens de la Terre*," in *Third Text* 14, Spring 1991, p. 85.

18. Ibid., p. 95.

19. Donald Tuzin, *The Voice of the Tambaran: Truth and Illusion in Illhita Arapesh Religion* (Berkeley: University of California Press, 1980), cited in Poppi, "From the Surburbs of the Global Village," p. 95.

20. Edmund Carpenter, *Oh, What a Blow That Phantom Gave Me!* (New York: Holt, Rinehart and Winston, 1973), p. 54. Cf. McEvilley, "Doctor, Lawyer, Indian Chief, 'Primitivism' in Twentieth Century Art at the Museum of Modern Art," p. 44.

problems of basing judgment on anthropological evidence, especially if one is intent on deconstructing Kantian axioms that relate to the conditions of alterity.

This is because it was Kant who in 1798 finally published his *Anthropology from a Pragmatic Point of View*,[21] containing the idea of a world citizen or (*Weltbürger*). Kant introduced anthropology as a branch of study to the German universities during the lectures of the winter semesters of 1772-73, thereby founding a science of man as an autonomous agent that is able to overcome his geographical limitations. Yet as Terry Cochran argued,[22] "the human being articulated in Anthropology belongs to the Western project of secularized thought." In this way the discipline of anthropology has been synonymous with the articulation of negotiations of alterity, with a Eurocentric bias, as argued by Tsenay Serequeberhan.[23]

Serequeberhan has posited the notion of a critique of Eurocentricism from a hermeneutical philosophical stance. He notes that Kant, writing in *Observations on the Feeling of the Beautiful and the Sublime*, differentiated the mental faculty of Europeans and non-Europeans as akin to the difference in the pigmentation of their skin, with the Europeans, and Germans, being ultimately superior to all others.[24] Elsewhere he has noted that the historical thinking of both Hegel and Marx[25] and the European philosophic tradition as a whole is *grosso modo* grounded, minus its "dark horses," on a Eurocentric "pre-text" of the humanity/historicity of human existence as a whole.

Postcolonial discourse has enabled artists to challenge such oppressive views and to engage in the various shifts in the siting of art away from the anonymity of the medium towards the space of the museum, from institutional frames to discursive networks. The often political urgency of the discourse of postcoloniality has its project in the deconstruction of dominant

21. Immanuel Kant, *Anthropology from a Pragmatic Point of View*, trans. Victor Lyle Dowdell, (Carbondale, IL: Southern Illinois University Press, 1978).

22. Terry Cochran, "The Emergence of Global Contemporaneity," *Diaspora*, (Toronto, University of Toronto Press Inc., 1996), 5:1, pp. 119-140.

23. Tsenay Serequeberhan, "The Critique of Eurocentrism," in Emmanuel Chikwudi Eze (ed.), *Postcolonial African Philosophy: a critical reader* (Cambridge Mass./Oxford: Blackwell Publishers, 1997), p. 148.

24. Immanuel Kant, *Observations on the Feeling of the Beautiful and the Sublime*, trans. John T. Goldthwait (Berkeley, CA: University of California Press, 1960), pp. 110-111.

25. Tsenay Serequeberhan, "The idea of Colonialism in Hegel's Philosophy of Right," in *International Philosophical Quarterly* 29:3, issue #15, September 1989; "Karl Marx and African emancipatory thought: a critique of Marx's Eurocentricmetaphysics," in *Praxis International* 10: 1 and 2, April and July 1990, cited in Serequeberhan, p. 154.

power structures that are mediated in the cultural realm. It is therefore not surprising that the analogy of mapping, born out of the alternative cartography of art in the late 1960s by notably Robert Smithson was reworked from gallery versus anti-gallery to the ethnological mapping of the institution.

Prime examples include the seminal work *Mining the Museum* by the African-American artist Fred Wilson in 1992. Such projects are paradoxically linked to the very institution that they seek to critique, since the projects must be seen in the very context that they seek to reform. To problematize matters further, such projects are often initiated or sponsored by the institution, and this can result in a weakening of the project's critical virtue.

The Primitivist, the Real Primitivist, and the African Fabric

The anthropologist and curator Clémentine Deliss held up one of Franz West's chairs from *Docustuhl '97* and announced to the audience that the African printed fabric on it was "not a good one."[26] The British artist Yinka Shonibare, she asserts, is a better exponent of the art of the fabric in question. One may question her claimed authority in relation to the value judgment of what "a good one" is. However, she does bring into focus the problems of exhibiting works that use transculturated or hybrid cultural objects in their conception within the framework of "inclusive" exhibitions such as the tenth documenta (dubbed dX) and the residual problems of "visibility" of the Other in such exhibitions. Perhaps we are indebted to Michel Foucault's assertion, in the seminal *The Order of Things* (1968), that unlike his predecessors, modern man is concerned with the unconscious (the Other):

An unveiling of the nonconscious is the truth of all the sciences of man.[27]

This very assertion is traceable to Marx and Freud in their construction of the opposition to the normalized Western psyche, which in turn identifies this opposition with the cultural Other. The subsequent, apparently happy marriage between the human sciences of anthropology and psychoanalysis

26. Clémentine Deliss gave a lecture titled "Metronome – Dakar, London, Berlin," as part of the 100 days – 100 guest, day 44, organized as part of documenta X, Kassel, 1997.

27. Michel Foucault, *The Order of Things* (New York: Vintage Books, 1970), cited in Foster, "The Artist as Ethnographer," p. 179.

has been forged largely on relating the cultural Other to the unconscious. Yet this "othering" of the self, through the elaboration of anthropology and psychoanalysis is evident within what Foster has termed "the buttress of the self through romantic opposition, [the extension] of the self through surrealist exploration,"[28] in fact does nothing for the understanding of the cultural Other. This was fundamental to the modern discourses, including modernism with its construction of the notion of the primitive.

The subsequent critique of the aforementioned sciences through postmodernist discourses also fails to address the problem in that such critique will always have the subject as its focus, be centered on that subject, while perhaps admittedly being concerned with centering the subject. This remains, for Foster, the main failing of postmodernism. For just as the cultural Other is appropriated within modernism, he and she are also subjected to the same fate within postmodernist thinking, since the problem remains that they continue to be idealized as the negation of the self. Along with this idealization comes the favoring of "the new subjects of history,"[29] who are drafted in to the critical discourse, only to be displaced before they really become historically effective.

In the eighties, the politics of difference and identity saw many artists from the diaspora gaining critical acclaim, under Derridean deconstructionism; before them it was the turn of the woman artist riding the high wave of the Lacanian feminist discourse. Yet no sooner did the discourses of the diaspora and multiculturalism seem to be making inroads than were they dropped in favor of the discourse of globalization. Overnight almost, identity ceases to be relevant, as they are deemed fragmentary and somewhat essentialist. What all this should teach us is that as long as the central subject of any critical discourse remains the self, the cultural Other will continue to find no real equality within such discourses. This is evident in wide adoption of anthropological theories as part of contemporary curatorial strategy. This stance is most evident when dealing with artists and objects from outside of the West. This is why the position of Deliss, at once a curator[30] and anthropologist, merits more discussion.

28. Foster, "The Artist as Ethnographer," p. 179.
29. Ibid.

When globalization was pronounced, its effect on other cultures naturally became a subject for the anthropologist. Ever attracted to the possibilities of subversion through the identification of the unconscious, the anthropologist develops, according to Foster, a kind of artist envy, thereby becoming "a self aware reader of culture understood as text."[31] The transition of the artist into the (ideal) reader of text was developed through the adoption of the Barthesian hypotheses of the play of text within myths enabling the anthropologist to be reborn as collagist, semiologist, avant-gardist, and even curator.

This "new anthropology" then identifies an ideal "artist-other" that in turn is presented in such a way as to reflect the ideal ego of the anthropologist. Hence the reason why Deliss can pronounce the fabric on the chairs as "not good" since, as she suggested, there is an artist "better" at using this fabric, Yinka Shonibare. Since Franz West and not Shonibare was chosen to participate in the documenta, perhaps the implication was that of a slight jab at the curator of dX, Catherine David? New anthropology, according to Foster, is then guilty of persisting in maintaining to understand entire cultural patterns by pretending to be deconstructive and critical of the old anthropology. Yet is this very same not true of art theory? Is the whole premise of his book *The Return of the Real* not an attempt to coopt the visible erosions made by other cultures on the Western, which has in turn resulted in a continuing crisis in the Western canon of art? This seems to be what Foster claims to have understood. To do this he adopts the model of *Nachträglichkeit* from Freud, and more importantly, the notion of distance and its disruption as an analytical framework in order to grapple with the cultural fabric of the now.

As Foster recalls, Benjamin borrowed the important opposition between the optical and the tactile within art history as developed in Alois Riegl's *The Late Roman Industry* (1901)[32] in his construction of "The Work of Art in the Age of Mechanical Reproduction" (1935-36). Foster is able to conclude the nature of the related value of distance within Benjamin's work. Within *One Way Street* (1928) that relationship is deemed to equate to the loss of distance,

30. Clémentine Deliss has been involved in the organisation of various exhibition dealing with the materiality of Africa in particular. She was the director of the Africa 95 Festival in the UK, and has been involved in various art workshops including TENQ in Senegal in particular. See Yinka Shonibare and Clémentine Deliss, "Debate," in *Third Text* 28/29, Autumn/Winter, 1994, pp. 199-202. Recently she has been seen combining her experience in fieldwork and travel with the conception of multicultural exhibitions as part of the Metronome Series.

31. Foster, "The Artist as Ethnographer," p. 180.

and within the "Work of Art" essay it is equated with the closing of distance. Yet it is the notion that "perspectives and prospects" underwrite critical distance that is of interest to Foster, as recalled from Erwin Panofsky's *Studies in Iconology* (1939).[33] In this way, Foster is able to construct simultaneously a method of analyzing closely what constitutes the artistic makeup of the now in terms of cultural influences, and yet maintain the important critical distance.

The question that Foster asks is how to make sense of "the questions of correct distance and critical history" that remain unanswered as a result of the impossibility of maintaining Panofsky's framework of "perspective as a true seeing and history as a scientific retrospect." To my mind, a more relevant and pressing question that Foster should be addressing in his book is: how do we relate to other cultures and their art and how do we address the problems that the various critical stances governing the return of this problem pose? Foster proposes the notion of a model of deferred action (as a reworking of Panofsky's "intellectual distance between the present and the past"[34]). He then concludes with questioning correct distance, while simultaneously proposing a model of parallactic framing (which tries to be contemporary) over Panofsky's claim of perspectival truth. In this way, it would seem that Foster, like the poststructuralists, nevertheless avoids the real essence of the predicament of the cultural Other.

By stressing that there is a need to guard against over-identification, he is in short proposing the (light) armoring of Lacan. There are dangers in advocating a "parallactic work that attempts to frame the framer as he or she frames the other."[35] It is possible, as a result, for the cultural Other to be repressed when the fascistic subject of Lacan armors itself in protection

32. For the admiration of Riegl by Benjamin see "Rigorous Study of Art" (1933), in *October* 47, Winter 1988. See also Thomas Y. Levin, "Walter Benjamin and the Theory of Art History" in the same issue; Margaret Iversen, *Alois Riegl: Art History and Theory* (Cambridge: MIT Press, 1993), pp. 15-16; and Antonia Lant, "Haptical Cinema," in *October* 74, Fall 1995. Cf. Foster, "Whatever Happened to Postmodernism?" p. 224.

33. Erwin Panofsky, *Studies in Iconology: Humanistic Themes in the Art of the Renaissance* (New York: Oxford University Press, 1939), pp. 27-28, cited in Foster, p. 224. Note also his footnote on the Hegelian dimension of the question of distance within art history: art must "strip the outside world of its stubborn foreignness" and this art history is to reflect on art as "a thing of the past," and "to show how the art of alien or past cultures could become part of the mental life of the present" (Hegel, *Introductory Lectures on aesthetics*, trans. Bernard Bosanquet [New Haven: Yale University Press, 1982], pp. 36, 13. Cf. Foster, p. 224. The emphases are mine, since this statement is fundamental to the core of this essay.

34. Erwin Panofsky, *Studies in Iconology*, pp. 27-28. Cited in Foster, p. 224.

against the fear of the body in pieces and fragmentation. It is therefore possible for the body to argue for purity, and a return to the armor, to reassert all things comforting to the self. This seems to be what Foster is suggesting as the unacceptable solution to the challenge of the Other to the authority of the Same.

For the cultural Other, artists of non-Western origins including those in the Western metropolitan diaspora, I wonder if these ideas are resonant with the continuing exclusions they continue to feel. What has happened to Fanon's unanswered call for recognition of the Other cultures? For all the purported virtues of Derridean deconstructionism and other poststructuralist tactics, the above question posed by Fanon remains valid. What seems to have happened is that the Other has been pushed further to the periphery and into that space identified by Foster as "a space of ideological escape from Western rationality."[36] However, how has this construction taken shape and what can be done to recover from it?

This situation came about since the Other provoked a crisis in Western identity, through the demand for recognition. Many avant-garde artists addressed their critical response to this situation through what Foster has called "the symbolic construct of primitivism, the fetishistic recognition-and-disavowal of this otherness."[37] Yet just as the death of the subject led to its reconstitution, so has the adoption of modes of institutional criticism allowed the "return" of the Other, just when it could have been eclipsed. In attempting to unravel what amounts to the questions of the visibilities of the Other and the associated problems, Hal Foster has suggested that there is a new artistic paradigm for artists from the "left" in the guise of the "artist as ethnographer." This is reminiscent of the old "author as producer" model of Walter Benjamin.[38]

What seems to connect the two situations is the criticism of the aestheticization of politics under fascism and the criticism of the capitalization of culture. Yet for all his elaboration this situation can best be understood by looking closely at the issues that necessitated what Annie Coombes has termed the process of "inventing the postcolonial."[39] There is no disputing

35. Foster, "The Artist as Ethnographer," p. 203.
36. Foster, "Whatever happened to Postmodernism," p. 217.
37. Ibid., p. 217.
38. Foster, "The Artist as Ethnographer," p. 172.

the fact that issues of authenticity and racial purity can be successfully challenged by the very idea of hybridity. However, it is also through this challenge that new meanings of authenticity and racial purity arise once more, especially with respect to the value of cultural objects. This is because such, according to Coombes, "cultural objects have become reinstated in recent times as the primary signifier of cultural, national, and ethnic identity."[40]

While there has been so much written about the cultural other, it is the "other within," or the diaspora artist that is the focus of this writing, whose situation is indicative of the remnant issues of visibility and identity. Often ignored in favor of the more fashionable "authentic" and external Other (as in *Magiciens*), the practice of the inner Other has shifted beyond the intricacies of what Foster has termed as that of the artist as ethnographer. Despite the efforts of much poststructuralist deconstructionism, the Other has either remained on the margins, being forgotten for more exotic variants, or simply been coopted by the institution in the return and sanctioning of the primitivist.

It is useful to outline some of the constructions of the cultural other within recent exhibition landmarks in the last two decades. What is the situation at the present moment and what can be learned from the lessons of such exhibitions like *"Primitivism,"* and the subsequent *Les Magiciens de la Terre*? The systematic fascination with other cultures and their artifacts are a much older tradition that is traceable to the times of the European Enlightenment era. Nowadays, it is fashionable to trace how the effects of Western culture are eroding and "contaminating" other cultures that are otherwise thought to be static in contrast to the dynamic West.

Problematic Aspects of the Anthropological Stance and the Globalization Model

In the new definitions, cultures from their very outset are deemed to be under various influences to such an extent that Self and Other cease to be discrete entities. The post-hybridity model of cultural syncretism of Becquer and Gatti recognizes that cultures from their very outset are deemed to be

39. Coombes, "Epilogue: Inventing the Post-Colonial," p. 217.
40. Ibid.

under various influences to such an extent that Self and Other cease to be discrete entities and have no "originary fixity."[41] What makes this model unsuitable for the analysis of current artistic production is the overt sociopolitical bias of the model. Writing in "Whatever happened to Postmodernism?" Hal Foster proposes a model of the now borrowed from Freud's notion of *Nachträglichkeit*.

Subjectivity in Freud is structured as a relay of anticipations and subsequent reconstructions of events that may become traumatic through the relay itself. The relationship between modernism and postmodernism, according to Foster, is constituted in a similar way. More importantly, by citing the Benjaminian theses on the anticipation of the next epoch and the revising of the previous one, Foster suggests that this is what constitutes the relationship between modernism and postmodernism. Many artists have chosen to make work that reaffirms the hybrid model of cultural self-determination, which is a common curatorial strategy. Within this strategy artists cross many cultural boundaries, assimilating objects that are loaded with associations in one culture for use in a totally different cultural context. This practice itself dates back to the Duchampian tactic of representing an object in an unfamiliar context in order to change the meaning of that object.

However, in the contemporary context, such a strategy is fraught with pitfalls, especially as there remain significant and unbalanced power structures between the center and the periphery, with visibility and its consequences remaining a sensitive issue. Exhibitions like *Les Magiciens de la Terre* were in many ways a postmodernist reaction to the modernist strategies *of "Primitivism" in 20th Century Art: An Affinity of the Tribal with the Modern*. Within the postmodernist milieu, difference was supposed to be celebrated, thereby overthrowing the universal tendencies of the modernist era. Further difficulties arise for artists who employ the model of the cultural hybrid object in the formulation of their work, encouraged somewhat by the current postcolonialist bias of curators who are interested in demonstrating the effects of globalization in the shaping of the artistic climate.

41. Marcos Becquer and José Gatti, "Elements of Vogue" in *Third Text* 16/17, Autumn/Winter 1991, p. 69. Cf. Hitchcock, p. 14.

In order to appreciate this shortcoming, it is only necessary to cite Foster's useful model of deferred action in order to grapple with the complexities of the now. If postmodernist tendencies are based on the (attempted) displacement of the modernist ones, and we are not certain that we are in a post-postmodernist era, it is valid to begin an analysis of certain modernist tendencies that remain today. The modernist exhibition strategy favored the avant-gardist pull towards universalizing formalist concerns, irrespective of their origins. This position is easy to understand if we remember that the history of modernity is intertwined with the ethics of the universal ideals that were proposed by Kant. The self-realizing tendency of the Universal Spirit and its polemical consequential concept of the Occidental superiority of Europeans over other races arguably then reached a peak within the "humanism" of Hegel. Modernity itself would arguably not have come about without globalization, a fact demonstrated in 1848 by Marx and Engels who realized the necessity of global expansion to the fundamental survival of the capitalist project.

Nowadays globalism is often used to describe the reviewed positions of intellectual, social, and cultural power, made possible in the wake of significant change due to the destabilizing effects of technological, economic, and cultural change, leading to the current situation termed as globalization. On the face of things, this situation should in theory be good news for the project of redistribution of power and the opening up of new opportunities. However, it remains a fact that globalization has not necessarily resulted in a great need within the West to understand non-Western cultures. This should not be so surprising since the whole notion of centrality still remains a key property of any economic system. The new technologies such as the new electronic commerce (e-commerce) and globalization have simply altered the spatial correlates of centrality, not eradicated it. This point is often overlooked in the optimistic adoption of the model of globalization within art, leading to the confusion that there are no more boundaries.

The boundaries have simply altered, according to Saskia Sassen, and along with them, "the hierarchies in the economic system that were often somewhat transparent correlates within the urban and in architecture" (and indeed within the art market) have been partly dematerialized through the "spatial virtualization of various important economic activities."[42] In this way, Saskia Sassen concludes that in actual fact what economic globaliza-

tion and the new information technologies have done is to create new spaces for centrality. For the art institution and artists to employ the strategies that have their framework connected to the idea of globalization, this important point must be taken on board. It follows that it is not possible to simply "decentralize" or even "deconstruct" the notion of centralized power within the arts system through an appeal to the questionable ethics of globalization.

This is part of the reason why art from other cultures continues to be misunderstood. Their histories continue to be excluded, as they are often drafted in as exotic plug-ins to the (still) centralized Western canon. For all the other parallel discourses that are happening globally, as witnessed in the impressive academic breadth of the 100 Days, 100 Guests lecture program of dX, everyone still has to talk the same language of Reason, and as related to the Western context. Sometimes the problems of "ideological patronage" surface, with the eternal Western paternalistic habits still evident within the "we shall give you a platform to tell your story to us, but in English, French or German please!" paradigm. It is usually forgotten, conveniently, that the very idea of modernity involved dialogue (however forced) with other cultures outside Europe. It is therefore illogical to deny these cultures to their modernity.

Consider the following example from French colonialism in West Africa about one hundred years ago. During this period, anyone born within the boundaries of Dakar, Rufisque, St. Louis, and Gorée in Senegal was considered a French citizen. Everyone else within French Colonial West Africa was deemed a French subject. Part of the reason was that the French influence on the cultural fabric of the country was greatest in these regions of Senegal. In a testament of this, to this day, every Senegalese born within the exact confines of this region (to the nearest meter, if necessary) has their birth certificates kept in Nantes.[43] The onset of national independence in Senegal brought the subsequent backlash on the country. Yet this rule

42. See Saskia Sassen, "The Topoi of E-Space: Global Cities and Global Value Chains," in *documenta X – the book: politics poetics* (Ostfidern-Riut: Cantz Verlag/Documenta and Museum Fridericianum Veranstaltstungs-GmbH), p. 737.

43. I acknowledge the help of my colleague, the Senegalese-born painter Bouna Seye now residing in Paris, who cited these facts out of personal knowledge during a studio residency that was organized by the author in London, August-September 1998.

remained in place for those born within the boundary confines described above. Naturally, those in this position migrated to France, in order to maintain the level of modernity that they were accustomed to under French rule.

Unknown to them they had suddenly been relinquished of their modernity on arrival in France. The problem was not because they were not French citizens, this was confirmed by their new French passports, rather it was because of where they were born. Many reside in France with the status of second-class French citizens while holding full French passports. They had gone from being from a culture that had been accustomed to the French version of modernity to the premodern. It is easy to understand why many of them who chose to become artists in France continue to fight for recognition for their work to be treated in much the same way as that of French and European artists. Many object to the application of "ideological patronage" that is often applied to the consumption of their artistic practice. They continue to be framed within the field of the cultural Other, outside the dominant discourse, with detrimental effect on their personal and professional progress. Yet their legitimate claim of "I am French too"[44] raises those very unanswered questions that Fanon posed all those years ago.

Post-*Magiciens de la Terre* and the Search for the Most Exotic Other

The situation after *Magiciens* was very interesting indeed, as many curators traveled the breadth of the planet in search of the postmodern Other. Various strategies were tried, in an attempt to correct the shortcomings of *Magiciens*. Notable examples include the valiant efforts of the 1993 artistic director of the Venice Biennale, Achille Bonito Oliva. In an attempt to change the rigid structures of the Pavilion of Nations that characterizes the (Euro) centric nature of the Biennale, Oliva proposed that each country propose a

44. This is the common reply to being interrogated by the French police, usually during a stop and search practice. The implied dilemma for the authoritarian is that the subject of the question is French, but does not look French and should not be French since (usually) he was born in Africa. The above applies to the nature of the art practice of the Paris-based artists Billy Bidjocka and Bouna Seye, who are well known on the "postcolonial" art circuit, but find it hard to break into the mainstream in France.

non-national to represent their Pavilion. Had this strategy succeeded, it would have meant an attempt to eradicate the problems of visibility of artists on the "margins." It would have meant a more transcultural Biennale, that hopefully would have corrected the main pitfall of *Magiciens*, giving visibility to the diaspora artists in the Western metropolis as well as those from non-Western cultures.

However, the project of Oliva failed not because of any major flaw in his ideals, but rather in the unwillingness of the major European countries to cooperate fully. Germany chose as their representative Hans Haacke, and Britain chose Richard Hamilton, who are both nationals. Hungary was one of the few countries that cooperated in that they chose Joseph Kosuth as their representative, although a less prominent diaspora artist would have fitted the aims of Oliva more perfectly. What were commendable were the aims of the main project "The Cardinal Points of Art" that focused on intermixing, hybridity, and multiculturalism as a transnational strategy. In particular, the revelation of hidden movements such as the Japanese Gutai Group was as refreshing as it was challenging on our notions of purity and authenticity. It was hoped that at least the project would form the basis of the next Biennale.

However, as usual, no sooner did it appear that we would be able to surmount the problematic of visibility of the Other than the following project was constructed as a backlash. Two years later the themes of *Magiciens* returned in the overtly exclusive tactics of the French artistic director Jean Clair, as it seems that the 1995 Biennale was conceived as a direct opposition to the preceding one. The very subject of the show, "Identity and Alterity," promised to "express the problems of a humanity undergoing profound change" as evident in the promotional information. However, in the end as Stella Santacatterina[45] pointed out, the result was nothing little more than "a conservative reaction to what, in the '93 Biennale, was perceived as dangerous and disordered." In particular, the unresolved function of the side project, Aperto '93, was transformed from being a reflection of works that were unresolved and contemporary into Clair's vision of a project that ignored the contemporary and looked into the future, without the inaccuracies of the past being resolved beforehand.

45. See Stella Santacatterina, "Identity of the Same: The Venice Biennale," in *Third Text* 31, Summer 1995, pp. 104-108.

The Decade Show (1990) in New York was a direct response to the problems of visibility as posed a year earlier in *Magiciens*. The curators assembled all the marginal museums like The Studio in Harlem, to participate with their artists on a stage of high visibility in an attempt to destabilize the status quo. While the artists concerned, most of whom would not have got such high-profile exposure, did become more visible, they nevertheless remained associated with marginalized museums. The solution here would simply have been to give the artists a showcase without association with the margins. While there exists a multiplicity of centers with associated parallel discourses that are often more complex than mere regionalism, the issue of visibility and at what cost to the artist this is achieved remains a sensitive one even today. Artists need visibility and interaction with the relevant discourses in order to develop, and it is perhaps for this reason that many artists shift from the margins to an intellectual center. A case to note here is the move from Pakistan of then painter Rasheed Araeen to London in the sixties. This move enabled Araeen to participate in and to some extent influence the debates that shaped British conceptual and minimalist art.

Araeen has also worked successfully in the cultural theory sector in Britain (being a founding editor of the influential *Third Text Magazine*). He also curated the exhibition *The Other Story* (1990, Hayward Gallery), as a direct result of his experiences of participating in and being critical of the failings of the *Magiciens* exhibition. Araeen's show focused exclusively on the new communities, in some ways redressing some of the problems of visibility of the diaspora artist within Britain. Artists from these communities and those from the Commonwealth were very prominent in the 1950s. However, there developed a significant shift from the 1950s onwards, because of the economic and cultural situation brought about by the Second World War. Britain ceased to look towards its old colonies of the Commonwealth, and shifted its aesthetic focus towards North America. As a result, artists from the Caribbean regions, who had enjoyed prominence and respect by the art establishment, became marginalized.

At this time a new breed of curators were graduating out of the Royal College of Art, who were heavily influenced by American modernism, and as a result were unfamiliar with the past reputation and context of the practices of diaspora artists such as Aubrey Williams. Gradually interest was lost by the 1970s in the aesthetics of such artists, in favor of what can be termed "Americanism." The disparity in visibility is best illustrated if we remember that

while Williams had to be content with being part of a recent group show at the Whitechapel Gallery, his contemporary, Patrick Heron, was being touted in the limelight of a solo show at the Tate Gallery. Unfortunately, despite a resurgence of the interest in Caribbean artists in the early eighties through the promotion of the works of Sonia Boyce and Keith Piper, amongst others, the new "internationalism" of the nineties has relegated the significance of their practice into the background. This is unfortunate as many of these artists challenged what was perceived as being the British experience, enriching our cultures in the process. It can be shown also that the recent successes of the current artists from the African diaspora, Yinka Shonibare and Chris Ofili, owe a lot to the groundbreaking efforts of Boyce, Piper, and others in conditioning the art institutions in Britain to be receptive to the nature of their practice.

In the end what we now have is the establishment of the new type of postcolonialist exhibition strategy which continues to favor the adapted models of hybridity and difference within the globalist milieu. These are commonly articulated as mere symptoms of what is termed as "postcolonial" (itself a dubious category) as opposed to the nature of "diasporic" formations. The fact that the very term postcolonial can often directly apply to those in the diaspora (which is itself a direct sign of hybridity and the possibilities of new communities) is ignored and attention is drawn to those on the margins. This is understandable, since the diaspora artists are often more disruptive to the centers of powers than their more distant siblings. This strategy effectively marginalized those artists within the diaspora, rendering them as the Other within. The reasons why the diaspora artists of African origin have greater visibility than their Caribbean counterparts is interesting in light of the foregoing, and worthy of research. To focus on the diaspora, would mean the acknowledgment of the often disruptive and transgressive powers of the art from these new communities and consequently the destabilization of the inherent models of racial purity.

However, the main problem that is caused by the adoption of the cultural hybrid is a paradoxical one. The same strategy that was meant to challenge the preconceived notions of racial purity and superiority enabled those very issues to resurface in a new form. At the end of this century, we seem to have turned a full circle back to its beginning as the strategies of primitivism are once again being promoted. Gerardo Mosquera has identified "a new thirst for exoticism as a result of the postmodern interest in the [cul-

tural Other], which has nevertheless opened up some space in the 'high art' circuits for vernacular and non-Western cultures."[46] This is often replicated by the insistent search by Western curators for the latest authentic variant of the cultural Other. Highly desirable variants at present include "contemporary" Chinese and African artists, and there are even plans to organize an exhibition under the title of *South Meets West* involving a bizarre mixture of "authentic" African artists who live on the continent, and their diaspora siblings who line in the West.[47] An exhibition of the Caribbean artists is much needed as a counterbalance.

Fragments from the Historical Development of Exoticism: The Significant Development of Exotic Rooms and Environments

The installations of West and Shonibare can be thought of as comprised of rooms and environments, much in the same way as any other work in a gallery. Both artists are dealing in essence with remappings of ideologies that were formed during the colonial eras. This is particularly true of Shonibare's *Victorian Philanthropist's Parlour*, 1996-97 (presented at the Second Johannesburg Biennale). In this work, the artist has reconstructed a typical philanthropist's room of the Victorian era and deconstructed the elements in the environments by incorporating imagery from contemporary black British culture in a strategy of ethnographic role-swapping.

The work therefore deconstructs the ethics that such rooms have come to symbolize. Shonibare's use of the African printed textile is a direct substitution of exotic wallpapers and fabrics that would have been present at that period. It is possible that these wallpapers within the room of a well-to-do philanthropist, such as the explorer Henry Morgan Stanley would have been supplied by an artist-designer like William Morris. The notion of the room, especially the presentation of rooms from foreign cultures, has been com-

46. Gerardo Mosquera, "The Marco Polo Syndrome: Some Problems around Art and Eurocentrism," in *Third Text* 21, Winter 1992-93, p. 35.
47. *South Meets West, African Avant Garde* is scheduled for premiering at the National Museum in Accra, Ghana, in 1999, before travelling to Kunsthalle Bern and the Historisches Museum Bern in Switzerland, with a proposed tour of Germany, Sweden, Austria, and The Netherlands.

mon practice since the 1880s. The importance of fabrics as an integral part of the presentation was very evident in *The Stanley and African Exhibition*, at the Victoria Gallery, London in 1890.

Analyzing the exhibition in the context of the constructions of the "spectacles of the empire," Coombes noted[48] that it constructed the viewer as an explorer of the faraway continent, by placing him in the position of the seasoned explorer. At this time, at the heights of the protest against the slave trade, Stanley had tactically affiliated himself with the Anti-Slavery League, which subsequently and reluctantly funded his exploration into Darkest Africa, on the understanding that he would promote its cause there. However, on his return, it became apparent that Stanley, the eternal opportunist and philanthropist, had in fact been in touch with the notorious indigenous slave trader Hamid Ibn Muhammad.[49] It is within the light of this information that I would like to undertake a reading of the *Philanthropist's Parlour*.

Shonibare subverts our normal interpretation of such a room, and confronts us with a scenario that attempts to rewrite the situation in the Victorian era by integrating the black cultural presence that is often either denied or signified purely in terms of trophies. Substituting contemporary trophies collaging prominent black football stars from the English Premier League, Shonibare is hinting at our continual obsession for culture hunting. Many of these players are admired in their respective football clubs, but would nevertheless not become the English national hero. Their relationships are very often constructed in a manner reminiscent of the master-slave dialectic.

It is the deconstruction of such a dialectic that, I believe, holds the key to the comprehension of the work. From the passage cited by Coombes, it is known that explorers do not really work in isolation, they needed contacts with like-minded commercial traders such as Hamid Ibn Muhammad. Yet the very act of trophy hunting is normally presented so as to exclude the involvement of the native entrepreneur. This is done so that the imagery of Africa could then be left as somewhat primitive. Evidence of any commercial activity, especially of the type that the colonialists were involved in, would mean that the "savages" of Africa were as developed at exploiting the

48. Coombes, "The Spectacle of Empire I: Expansionism and Philanthropy at the Stanley and Africa Exhibition," pp. (63-83), p. 69.
49. *Anti-Slavery Reporter*, London, March to April 1890, p. 83. Cf. Ibid., p. 68.

natural (and human) resources as the Europeans. Although artifacts used within the slave trade were exhibited, the sophistication of this barbaric practice was denied by the Anti-Slavery League.

Such an association also hints at a problematic review of the economic enterprise of that time, the slave trade. Hamid Ibn Muhammad and many more like him were actively involved in that grotesque inhuman act of commercializing blacks, essentially the black male, for profit. It may be possible that Shonibare himself did not consider that such aspects could be read into this work. The effect of such a reading for me represents the tentative steps at reconciling the effect of the slave trade and acknowledging the resulting trauma that clearly plagues the African diaspora to this day. Such readings should be the activity of any proposed Philosophy of Contemporary African Art, for which I argue for in the next section. Slavery is talked about, but not as an inhuman act that also implicated indigenous slave traders like Hamid Ibn Muhammad. Such admittance would forever shatter the myth of a totally homogeneous African identity as historically constructed.

I realize that these are delicate and difficult matters to read into an artwork. Yet I feel it necessary to do so in order to grasp the differences between the artistic intent and its reception as mediated by the demands of a specific environment such as the presentation of Shonibare's work at the last Biennale of Johannesburg, South Africa. The title of the exhibition project itself was *Trade Routes: History and Geography,* hinting at the postcolonial premise of the show. The second Biennale would be a totally different proposition from the lackluster and disjointed first. The controversial appointment of New York-based; Nigerian-born artistic director Okwui Enwezor resulted in the conception of an exhibition that many believe has finally buried the ghosts of *Les Magiciens de la Terre*. What is certain, however, is that the show was premised on the postcolonial perception of hybridity and its deployment in the age of globalization. As such the artists working with transculturated objects were privileged. In such an environment, Shonibare's presentation was given prominence, as the organizers in effect performed a double deconstruction in order to achieve their sociopolitical aims. This way, the dangers of fetishizing the "in-between spaces" therefore materialized, preventing a meaningful critique of the work on account of its "appropriateness" for the context. Elaborating on such dangers should also be the focus of any future project of a Philosophy of Contemporary African Art.

Closing Remarks and Wider Thoughts

How to unravel the problems that the transculturated object and its setting within centers of powers pose is the aim of this closing section. I have attempted to outline the various failures of negotiating alterity within mainstream Westernized art history in a space that cannot hope to do the scale of the problem any justice. In this final section, I propose a beginning. A development of a new way of philosophizing about the art that is born out of alterity. The development of the branch of Postcolonial African Philosophy has left a space for the application of such thinking to the works of artists who are African, Afro-Caribbean, African-American, and those who are involved with the visual materiality of these regions.

The failure of existing critical discourse to address central issues such as visibility has meant that it is perhaps time to turn to a mode of thinking that would finally bury the demands of emancipation. It is time also to surpass the negative criticality that has been necessary in any conceptual endeavor that relied on conventional ontological analysis aimed at winning the "battle of visibility." In this respect, I have offered a radically different reading of the work of Shonibare from a perspective different from that possible within institutional liberalism. Tsenay Serequeberhan asserted that Contemporary African Philosophy must challenge the situation of falsified "liberation" and "freedom" and instead "put behind the subordinate status imposed on it by European colonialism and perpetuated by neocolonialism."[50] In much the same way I am arguing for a similar project for contemporary African art that moves beyond the current contemporary variety that is subordinated to Western art.

An initial philosophical appeal will be made to Emmanuel Levinas, in order to propose some aspects that any future Philosophy of Contemporary African Art should be concerned with, through an analysis of the encounter of the author with the work of Franz West at documenta X. Robert Bernasconi was correct in quoting Levinas to show that, like many of continental philosophy's finest minds, he continues to exhibit a Eurocentric view: "I always say – but in private – that the Greeks and the Bible are all that is serious in humanity. Everything else is dancing."[51] Bernasconi has

50. Tsenay Serequeberhan, *The Hermeneutics of African Philosophy: Horizon and Discourse* (Routledge: London/New York, 1994), p. 16.

argued elsewhere for the overlooking of Levinas's personal prejudice in favor of his powerful thinking, which can be adapted to provide a platform for cross-cultural encounter.[52] In such a way perhaps we could begin to approach the era of genuine equality for the cultural Other and its art, without threat to the Same and its art.

The Other, as Levinas recognized, has generally been regarded as something provisionally separate from the Same, even though ultimately reconcilable with it. Otherness, alterity, surfaces as a temporal interruption to be eliminated as it is incorporated into or reduced to sameness. Such strategies continue to multiply as we continue to search for sameness, since the climate of culture now is subjected to another universal tendency – globalization. The aim here is not to heap criticism on any particular curatorial strategy, but rather to develop a way of thinking of the significance of a meaningful cultural encounter. In order to do this, it is necessary to look for another way of thinking about Being and beyond, without falling into the pitfall of manufacturing another Being.

In the following analysis, the lucid elaboration on Levinas's text by Davis is cited as a framework. Drawing largely on ordinary language, Levinas asserts in *Otherwise than Being or Beyond Essence* (hereafter abbreviated as OB[53]) that words are interconnected within a language that consists of a vast textual chain. However, words according to Levinas never seem to be able to capture that which lies beyond the text, or beyond Being. The immediate implication of this is that all theories of difference, otherness, and alterity have no way of capturing (or understanding) the Other, the art of the Other.

Pertinent problems remain for Foster concerning the distance between Being and beyond Being, since "a reductive over-identification with the other is not desirable either. Far worse, however, is a murderous disidentification

51. Emmanuel Levinas, "Intention, Ereignis und der Andere: Gespräch Zwischen Emmanuel Levinas und Christoph von Wolzogen," in *Humanismus des anderen Menschen* (Hamburg: Felix Meiner, 1989), p. 140. Cited in "African Philosophy v. Continental Philosophy" in Emmanuel Chikwudi Eze (ed.), *Postcolonial African Philosophy: a critical reader*, p. 185.

52. Robert Bernasconi, "Who is my neighbor? Who is the Other? Questioning 'the generosity of Western thought,'" in *Ethics and Responsibility in the Phenomenological Tradition* (The Ninth Annual Symposium of the Simon Silverman Phenomenology, Center Duquesne University, Pittsburgh, 1992), pp. 1-31. Cited in "African Philosophy v. Continental Philosophy, in Emmanuel Chikwudi Eze (ed.), *Postcolonial African Philosophy: a critical reader*, p. 185.

53. Emmanuel Levinas, *Otherwise than Being or Beyond Essence*, 1974, trans. Alphonso Lingis (The Hague: Martinus Nijhoff, 1981). Cf. Colin Davis, *Levinas: An Introduction* (Cambridge and Oxford: Polity Press/Blackwell Publishers Ltd., 1996).

from the other."[54] This in turn is manifested in cultural politics being stuck at this impasse, meriting the call for critical distancing. Foster's efforts are admirable in recognizing, as many had done before him in any case, that something has to be done to "unstick" the current situation. However, his regression to the model of deferred action proved inadequate to address real issues of alterity, since this model still has a Eurocentric world art history view. This is why it is important to return to Levinas who recognized early on the impossibility of comprehending the beyond Being. The example from OB that describes a debt that increases as it is paid off is perhaps not as bizarre as it first seems (27/12).[55] Is this not akin to what we do when we resort to the paternalistic mode of giving the Other, out of our responsibility, a platform for expression in the many forums, residencies, transcultural exhibitions that are sited in the West and so on? Rather than decreasing our feeling of guilt, such aims do no more than deepen it, through the failure to achieve the set aims.

The key here is the discrepancy between what we intended to do, and how things actually turned out in the heat of our encounter with the Other. Levinas sidesteps the inherent difficulties within ontology of moving beyond Being, by proposing in OB the distinction between the Said and Saying (19/7).[56] Levinas is trying to approach something that does not belong to the order of Being, the other-than-Being, without transforming it into simply another being. He asserts that philosophy has been largely concerned with the Said in the form of a discourse about the world, truth, Being, Self, and so on. In such a way, Levinas reminds us that it is easy to miss the importance of Saying, which is governed by utterances, structures, and events in which I am exposed to the Other as a speaker or receiver of discourse. My exposure to the Other, or the situation (context) in which I am exposed to the Other, can condition what is Said. It can also condition my thoughts, my view of the world, what I am, what I take to be truthful, and what the nature of existence is.

Therefore when I approach the work of Franz West, *Docustuhl '97* in the auditorium of dX, I am exposed to the Other under the auspices of the discourse of globalization that aimed at centering the Other, as explicated by the dis-

54. Ibid. p. 203.
55. Davis, "Ethical Language," p. 72.
56. Ibid. p. 74.

course presented by the various speakers. Furthermore, this discourse conditions me to believe that Africa, especially, is indeed at the center not the periphery of things, holding an influential position in contemporary art discourse. This is shown to me by the importance given to the presence of eminent speakers such as Wole Soyinka, the Nigerian critic and writer who closed the lecture program, and Edward Said, who opened it.

The very seats that one occupies are blazoned in distant fashion with a signifier of West African contemporary culture – the printed waxed batik fabric. The fabric and its patterns are the only thing one notices about the seating, as they are typical of the aims of their creator, Franz West:

> … this is the art of today, lying down on the bed looking up into space. It doesn't matter what the art looks like but how it's used. The important thing is to find a place for art, not a description.[57]

In my own interview with West, the statement above runs through his current approach to his work, belying a structured and historical approach with the casual.[58] The participatory aspect of the viewer has been part of a conscious act of relinquishing the authorship of the work for West, which grew out of the dominant strategy of Vienna Aktionismus. The desire to tease the viewers out of their habitual practice within the gallery has been strong for West.

Yet the Saying of this encounter with West in the auditorium is that Africa is only important as long as it is made to fit into the framework of the auditorium and within the topoi of the globalist discourse. However, since Saying conditions what can be Said, in visual terms, this equates the drive to center the Other prominently (as was often done in previous documentas), with the motive to demonstrate my generosity. This can be true if this centering has no way of challenging the status quo. Saying is never fully present in the Said, but the Said remains the only access we have to the Saying, which leaves a trace on the Said.

If the Saying of this situation equates to me being magnanimous in fulfilling my responsibility to the Other, through the provision of a platform from which to communicate with the Same, then this must, according to Lev-

57. Franz West interviewed by Iwona Blazwick, James Lingwood and Andrea Schlieker, in *Possible Worlds: Sculpture from Europe* (London: Institute of Contemporary Art/Serpentine Gallery, 1990), p. 83, p. 85. Cf Lyne Cooke, "Franz West: Rest," at <www.diacenter.org/exhibs/West/essay.html>.
58. Franz West, interviewed by the author, for a video documentary in progress titled "What's in a Print?," as at 5.9.98, in his studio in Vienna, on 26.7.98.

inas, condition what is communicated and how this is done. If I choose to Other myself through identification with the Other's cause, I may be able to distinguish (in my Saying) between how the Saying will appear to others. A common strategy of Othering of the Same is that of adopting a hybrid or transculturated object. In recent times the African wax printed batik has become popular material for many artists, including West.

This strategy is perhaps understandable since the printed fabric itself has a mixed origin; the batik textiles are sometimes worn in Africa as a symbol of defiance against the old colonial domination.[59] The same fabrics are sometimes worn here in the West in solidarity with the "African" struggles for identity. They replace, in Africa, the more cumbersome, traditional woven African textile for everyday use.[60] Nowadays designs are reexported back to Holland to be produced. From Holland, they reach Manchester in England, where they are then shipped to Africa. As such they are culturally loaded with interplay of culturally specific discourses, and their use is sometimes set against the dominant cultural ideology.

In the interview with West, he himself admitted that he was initially introduced to the Senegalese fancy prints through the recommendation of Clémentine Deliss. His apparent ignorance of the history and ambivalence to the discourse of the fabric was worrying. The patterns in the fabric for his work have been identified by the painter Bouna Seye as being synonymous with the work of the painter El Hadji Sy (a founding member of TENQ, an artist workshop in St. Louis, Senegal). Deliss has been involved in organizing workshops in TENQ and would know Sy. This is perhaps one way that I could justify the ethical decision of commissioning an artist best fitting my intended Said, to produce an artwork that signifies the presence or even aura of another culture, as a visible means of my own othering.

59. In Burkina Faso, for example, the Faso, a particular form of native attire, was encouraged as a replacement of the Western. Naturally, this also served to bolster the economy, while resisting the signifier of colonial domination.

60. The most highly regarded types are those fabrics that originate from the Dutch wax process, which originates from Indonesia and is made by a company called Vlisco. The Gold Coast was a refreshment station for the East Indies Company ships, which among their goods brought batiks from Java. These were such a success with the local population that in time the Dutch decided to produce them, in a variation of the batik process: out of this grew Vlisco. I am indebted for this information to J. Nederveen Pieterse (J. Nederveen Pieterse [jnp@xs4all.nl]) in Holland for this information, and help into researching the mixed origins of the fabric.

In this way, the encounter with the Other is reduced to traces of a temporal nature within the system of power relations. What Levinas proposed in OB is a rather different form of reduction – one from the Said to the Saying. Davis notes that Levinas's subject within such an encounter is also somewhat different in construct to the normal one since it is neither "the humanist or existentialist originator of its own actions and meanings, but neither is it the structuralist or poststructuralist battleground of structures and ideologies."[61] It is during this prior phase that the Same is constituted by and as exposed to the Other. This is equitable with my encounter with the work of the Other within the auditorium of dX.

In this encounter, Levinas argues that the subject becomes deposed and desituated as consciousness and intentionality lose their status as the privileged sites of rational analysis. The subject is unique, however, and in Levinassian terms it is not the site of consciousness, intentionality, interiority, commitment, choice, and so on. Yet this appeal to Levinas does have its shortcomings, for as Davis asserts, in saying this, my reading of my encounter with the work of West may have been colored by the "Levinas effect."[62] This is because it is not possible to simply appropriate Levinas's philosophy blindly, for we will always find something that appeals to our own means, only to be disappointed when our projections fail to be fully realized as his difficult texts evade us with their transparency.

What I am searching for in my reading of Levinas are agencies within a practical context. To conclude, I would like to cite a more practical application of the Levinassian philosophy as represented in *Jews and Blacks* by Michael Lerner and Cornel West.[63] In this book, two of America's most prominent intellectuals exchange frank ideas on issues as wide ranging as Louis Farrakhan and the Million Man March to whether Jews should identify themselves as "white." What is very moving is the frankness at which they negotiate the painful divisions that characterize contemporary relations of alterity in America, and which prove useful in the analysis of Otherness. What attracts me are the convincing arguments for respecting difference and Otherness, and being prepared to work through overcoming the

61. Davis, "Ethical Language: Otherwise than Being or Beyond Essence," p. 77.
62. Davis, "Levinas and his Readers," p. 141.
63. Michael Lerner and Cornell West, *Jews and Blacks, A Dialogue on Race, Religion, and Culture in America* (New York: Plume/Penguin, 1996).

authoritarian and societal demands that the Same and the Other be kept separate.

In this respect, the best lesson we could learn from a Levinas in contemporary society is that the text, art, or culture of the Other is always available for appropriation by the Same, as we have seen in the work of Franz West. The result of this appropriation or any other self "othering" process should not produce the rather dangerous critical distancing that Hal Foster argues for, but should, as Davis suggests, allow us to reaffirm our own identity since the Levinassian text "mirrors the frailty and strength of the Other."[64] We may be able to comprehend more readily the motives of Yinka Shonibare rather than Franz West in their appropriation of the African printed fabric for their work. This is proof enough that alterity is alive and relevant despite the claims of poststructuralist discourse mediated by the era of globalization. Levinas shows us that alterity will always continue to resist the authority of the Same. The encounter between Michael Lerner and Cornel West removes any traces of ineffective politically correct liberalism of "giving the Other a voice, of trying to find an idiom in which the Other may be heard through the chatter which serves to silence it."[65]

Why can we not adopt the encounter of West and Lerner as a framework for the construction of the ideologies of cultural encounters within the institution of art, namely transcultural art exhibitions? In order to do this I reassert the requirement of a discourse of the Philosophy of Contemporary African Art that would have repercussions surpassing the current subordinate requirement of "authenticity" that is directed at the unsatisfactory variety of contemporary African art currently being promoted. Such a discourse would also free the diaspora artist from the burden of emancipation and the unspoken consensus that restricts the scope of their practice within the realms of stereotypical notions of alterity.

The diaspora artist Chris Ofili has a good possibility of becoming the first artist of African descent to be awarded the prestigious Turner Prize.[66] However we need to realize that this does not necessarily mean that the Other has

64. Davis, "Levinas and his Readers," p. 141.
65. Davis, "Conclusion," p. 144.
66. See on-line press release dated 1 July 1998, at: <www.tate.org.uk/info/menui_p2.htm>, the winner of the £20,000 prize will be announced at the Tate Gallery on December 1, 1998, during a live broadcast by Channel 4. Work by the shortlisted artists will be shown in an exhibition at the Tate Gallery October 28, 1998 - January 10, 1999.

been reduced to the Same in the terms of classical philosophical discourse. It may be due more to the "… new thirst for exoticism as a result of the post-modern interest in the [cultural Other]" that Gerardo Mosquera elaborated.[67]

67. Mosquera, "The Marco Polo Syndrome: Some Problems around Art and Eurocentrism," p. 35. The renewed interest in the exotic merits a brief charting of its historical origins in relation to art. Exoticism was a phenomenon that was already commonplace within early seventeenth-century England in particular. The writings arising out of the sea forays of George Sandy into the Mediterranean and William Prescott's conquistador-style narratives of the first contact between the Incas and the Aztecs and the European come to mind. The world then was a place of strange creatures, even more so than those introduced in Pliny's problematic but influential *Natural History*. While the powers of Europe were busy laying waste to other cultures for material progress, the function of the exotic became a comforting signifier of the refinement and civilized attributes of Europe. It was necessary to paint a picture of the outside world as inhabited by long-tailed men, some able to perform fantastic feats like clutching their heads under their arms while having a conversation with each other. Then there were the sciopods (having more than two legs), amazons (possessing wildly impressive physical power) and astomis (who are able to live merely from smelling apples). In much the same way as Freud demonstrated that the Wolf Man represented the limits of the unconscious, to which an ordered society should not sink, the imagery of the cultural "Other" functioned in much the same way from the Renaissance through to the nineteenth century. See G.S. Rousseau and Roy Porter, "Introduction: approaching enlightenment exoticism" in G.S. Rousseau and Roy Porter (eds.), *Exoticism in the Enlightenment* (Manchester and New York: Manchester University Press, 1990).

From the series, *Eine Reise*, detail, 1991

Oladélé Ajiboyé Bamgboyé

Observations on Performative Simulation within African Iron Smelting

This essay is adapted from a lecture presented during the closing lectures of the exhibition *Laboratorium*,[1] and is based on the concepts that informed my multimedia computer screen-based work that was presented as part of that exhibition. Within the field of the arts, the influence of technology increases with every new survey of contemporary art practice. *Laboratorium* asked many questions, but the most pertinent was that of the laboratory, a phenomenon that currently grips many scientifically informed art productions. It is important to remember that historically, especially since the Enlightenment era, the relationship between science and art has been one that has been thoroughly explored, if often with questionable results.

Therefore when we consider the complexities thrown up by the need to make sense of culture during the purported era of globalization, the necessity of a cultural critique of technology as a culture that saturates our world, leading to its ascendance as the dominant discourse in politics, medicine, the media, religion, and everyday life,[2] becomes ever more pressing.[3] If we are also to consider the relationship between the laboratory and the studio and even the world as a whole, then interpretation, simulation, and the element of the performative within the scientific analysis of fieldwork data, or perhaps even exhibition data, is a necessary tool with which we are perhaps able to make clearer sense of our milieu.

These issues are well illustrated by the specific case of the "rediscovery" of the ancient art of African iron smelting by Western archaeologists, as illustrated in the cover photograph of *American Scientist* (November-December 1995

1. *Laboratorium* June 27-October 3, 1999, curated by Hans Ulrich Obrist and Barbara Vanderlinden, hosted at the Provinciaal Museum voor Fotografie and different locations in the city of Antwerp, Belgium. Information at <http://laboratorium.antwerpenopen.be.>
2. For a concise overview of the importance, complexities, and necessities of a cultural critique of the sciences and technology, see Michael Menser and Stanley Aronowitz, *Technoscience and Cyberculture*, (Routledge, 1996).
3. To begin with I have associated myself with the "we" of the dominant Western culture. As someone sited in a Western diaspora, using the apparatus of critique available to that system.

issue). The cover photograph shows a restaging that is deemed typical of the ironmaking tradition of the Haya people of Northwest Tanzania, Africa. We are presented with a photograph of six men, with an elder prominent in the left of the picture, gathered around what looks like a furnace within an open field, with the American Scientist prominently and ironically hovering in the African sky. The process that is involved is thought to be more than 2,200 years old. Many commentators have even dated the development of early Saharan metallurgy as being the forerunner of those in all other cultures. Richard Hooker noted that as early as "1400 BC, East Africans began producing steel in carbon furnaces (steel was invented in the West in the eighteenth century)."[4]

However, while advances in the nature of iron smelting in Africa merit more attention, it is rather the mode of the photograph itself seems to reinforce our sense of mystery, on the one hand, while it seems quite obvious that the participants are only too aware of our directive gaze, seemingly being content with playing with the fact that we are ever so uncomfortable with that gaze. It would seem, in the light of being told that what we are witnessing is a reconstruction from the memory of the Hayan elders, that the element of performance is important in understanding the ideology behind this rather prominent representation of the Haya.

In order to understand better what seems to be going on in the photograph and why it is important, it is useful to draw on a critical appraisal of the representations of culture through the performative within the technological realm. This essay aims to demonstrate how the very process of ironmaking in Africa has inevitably been subjected to questionable gender metaphor within contemporary anthropological critique and how this positioning also continues to situate the process of ironmaking in Africa more as a subset of ritual and alchemy rather than as a technocultural phenomenon.

The presentation of the technologically advanced Hayan ironmaking process through the apparent radicalization of the research into the very nature of the process of African ironmaking is also not without apparent subversive underpinnings that aim to promote the widely held myths about the nature of technology within Africa. Archaeologists, we are informed in the article:

4. Richard Hooker and the Washington State University, in "Civilizations in Africa: The Iron Age South of the Sahara," located at <http://www.wsu.edu/~dee/CIVAFRCA/IRONAGE.HTM>, on Tuesday, February 29, 2000.

have long held that ironmaking technology spread by diffusion from a single point of origin, probably in what is now Turkey. But author Peter R. Schmidt began 25 years ago to question the application of this theory to Africa, where slags from ancient iron smelts appeared to have a metallurgy different than found in the remnants of ancient smelting in Europe. Now metallurgical analysis of iron made in ancient and modern times by the Haya people of Tanzania supports this view and extends the understanding of African iron smelting.[5]

This would seem to place the Haya people in that seemingly enviable position of having been recognized by the Western scientists as having a distinct technology of their own that merits contemporary academic attention and research. However, closer analysis of the statement would seem to situate it not within the realm of scientific discovery, but rather as a natural extension of the long tradition within science of the "theater of proof." During Victorian times, it was common practice to demonstrate publicly certain empirical truths. The lone scientist often did this, in order to be rewarded by an academic peer-group. It is notable that such presentations were often done in the form of a public performance of wonderment and mystery, in much the same way as that presented to us in the cover photograph of the *American Scientist* article.

Bruno Latour, during the lecture "Spontaneous Generation, Louis Pasteur's Sorbonne Lecture in 1864,"[6] demonstrated the pragmatic effectiveness of the theatrical aspect of such demonstrations. The main focus here is on questioning the classical issue of remaining true to the perceived truths as revealed by scientific data from staged experiments, as opposed to the issue of being able to prove certain truths through experimentation. The difference between these two positions is significant since within it lays the fulcrum of lone research and its relationship to the ego of the scientist. While we learn that the conclusion of the Schmidt and Childs' article makes us to finally realize that "Sub-Saharan African iron technology had to cope with a difficult iron chemistry," it seems also valid to state that what is being achieved is not the vindication of the scientific progress of the Haya, but

5. See <http://www.amsci.org/amsci/articles/95articles/PSchmidt.html> for more details.
6. Bruno Latour, "Spontaneous Generation, Louis Pasteur's Sorbonne Lecture in 1864," lecture delivered on June 26, 1999, at the Plantijn-Hogeschool van de Provincie Antwerpen, Antwerp, Belgium, on the occasion of the exhibition *Laboratorium*.

rather a self-regulated critique that is symptomatic of the tradition of the analysis, interpretation, and manipulation of certain *truths* as revealed by scientific fieldwork, for the academic distinction of the scientist.

"Experts" such as Schmidt and Childs are deemed "radical" since perhaps it is still within the discipline of field archaeology that it is possible to construct exotic belief systems through the reworking of the materiality of a given culture. Bringing metallic samples that were made by the native specialists for scientific analysis to the technically advanced Westernized world is a continuing practice employed by archaeologists, a mode of working that sustains the perceived technological gap, justifying the ransacking of natural resources at their point of production. On the one hand, we credit these technologically challenging natives with inventing a process that predates its Western equivalent, while on the other, their very representation continues to feed our insatiable appetite for imagery out of Africa that exudes a bizarre wonderment, lacking somehow in order. We supply the order and corroboration by prominently showcasing how their efforts have met with our approval, in a temporary act of surrealistic self-othering. We show the whole world what they achieved, because, despite the fact that we could not achieve as much given their limited resources, we are nevertheless in awe of their natural ingenuity and industry.

This may well explain why we persuade them to reconstruct, from memory and on our terms, a process that is long depleted, and that may not have been of interest to them without our intervention, as a mode of sustaining our construction of their technological prowess as being based not on scientific truths but rather on the performative, the supernatural, and the irrational. Evidence is provided in the natural field, produced under skills that seem to defy logic and all that we know of their civilization, in a manner that seems somehow second nature to them, and that needs the rationality and order that is only provided by being validated out of the scientific interpretation that is deemed to be beyond them. This act of patronage enables us to validate once more the Hegelian hierarchy of the superiority of science and reason over nature, of us over them.

Nature is all the more subordinate to science and reason, if the natural can be projected onto the Other. Such projections are then invested with the authority to reduce the Other's reason and even science into the natural. In this way we could always engulf all elements of rationality in the Other in the thick mist of mysticism and wonderment. This is an efficient way to sys-

tematically catalogue, on the one hand, the rationality of the Other, while simultaneously ensuring that such rationality remains incomparable to our own. Such an ethic forms a central part of fieldwork and the interpretation of the collected data, in the construction of a supposed "knowledge" of the Other, leading to many deeply held generalizations. In particular, consider Eugenia Herbert's citing of the findings of two of the "most outstanding" young archaeologists, the McIntoshs, who proudly declare:

> We believe it will be impossible… to understand the emergence of smiths without giving as much research weight to their occult knowledge as to their social standing or sources of ore and fuel.[7]

While their postulation is valid, it is the analysis of the motives behind their assertion and the impact of this on how the nature of African smithing technology is perceived that is of interest here. It is such assertions that have been responsible for the systematic focus on the gynecomorphic nature of the furnaces, as a working model buttressed with the mysticism of the occult (need I say it – the Voodoo factor). The hidden agenda here is to demonstrate that African technology is situated within the comparable ethics of mediaeval alchemy. In this respect, the more technologically oriented research of Schmidt and Childs, though not without its own flaws, is nevertheless more progressive in breaking down the entrenched opinions that continue to exist in Westernized ethnographic practice.

Opinions that seek to highlight and focus solely on the mythical nature of African iron smithing, however, are exposed within a closer analysis of Herbert's equation of the insertion of leaves into the body of the furnace during the reconstructed smithing process, with the offering of a "sacrifice" to the furnace itself. This association is itself a doctrinaire view that contributes to the ethical stance leading to the optically colored view of Africa as "forever same." Many may remember from elementary chemistry that iron smelting essentially involves the reduction of iron ore (which contains impurities and is found in nature) by carbon monoxide into pure metallic iron. In simplified terms, what the African smiths seemed to have done is to merely use the leaves to limit the flow of oxygen into the furnace. This technique in turn produces the bluish smoke containing the carbon monoxide, which, as we know, produces the metallic iron.

7. Eugena W. Herbert, *Iron Gender and Power: Rituals of Transformation in African Societies* (Bloomington and Indianapolis: Indiana University Press, 1993). See also note 12.

It is also possible to reduce the iron ores by smelting them with coke (carbon), with the addition of substances containing limestone that further promote the smelting process and the formation of what is called a slag, which helps to dissolve many of the impurities that are present in the naturally occurring iron ore. The quality of the desired metallic iron is then directly dependent on the efficiency of the slag to remove the impurities. Researchers like Schmidt and Childs have demonstrated elsewhere that the African smiths, despite facing difficult iron ore chemistry, were nevertheless able to produce the highest purity of metallic iron. However, here ends the chemistry lesson, since what I am most interested in is the effect of the insertion of the leaves on the coloring of the imagination of the Western researcher watching and recording the reenactment of an ancient process largely reconstructed from memory by smiths who are represented by a group of predominantly male-dominated elders.

In Peggy Phelan's book, *Unmarked, the politics of performance*, we are reminded:

> Performance's life is in the present. Performance can't be said, recorded, documented, or otherwise participate in the representation of representations: once it does so, it becomes something other than performance.[8]

In the light of this, the importance of this assertion in relation to the events that led to the production and presentation of the cover photograph of the smelters becomes clearer. It is possible to argue that the iron smelting reconstructions have a significant performative element to them since all concerned know that these smeltings are often staged specially for the collection of data to be analyzed. The extra presence of the documentary camera crews that often accompany the field ethnologists and researchers can conceivably have an effect on the behavior of the smelters. Many recordings were actually staged in collaborative with the respective African governments, also for the purposes of broadcasting on television, as recently as the mid-1960s, while the cover photograph in question is even more recent. After all, we are talking of reconstructions of ancient processes that have all but vanished in a context where the performers are aware of the power of the mass media. This is demonstrated by the fact that in 1960, the Central African Film Unit in Zambia, through the research auspices of Chaplin, carried out filming of an ironworking reconstruction. We are dealing with a

8. Peggy Phelan, *Unmarkes, the politics of performance* (Routledge, 1993), chapter 7.

more complex situation, in which the performative model is more relevant than most Western researchers want us to realize. Power is at stake here.⁹

Yet what remains unbelievable is the rigid assumption that the performing smelters are somehow impervious to the fact that they are part of a large restaging which will be broadcast abroad and will be accessible in their own countries. Without laboring the point any further, the stance of the researchers is to ignore the effect of modernity within the African context, to brush the effects aside and to forge ahead with a regime which aims at finding clues that allow a premodern image of the context to be constructed. It is within this regime that it is possible to underplay the performative element of the restaging. In this way, focus is directed towards the end results, thereby playing down any effects that the reactions of the participants may have on the technique or presentation. While such matters may not directly affect the end result, they do however; influence our reading of the process, as well as the power relations that are invoked. The end result is the promotion of the metonymic otherness of Africa.

In order to better comprehend the nature of the power relations that are invoked within the restaging, it is useful to recall Peggy Phelan's postulation that since the performative body is a metonymic of the self, of voice, the performative is also able to resist metaphor. A valid analogy is therefore possible between the silenced female body (from Molière's *Don Juan*)¹⁰ and the silent performers of the cover of the article in the *American Scientist*. An important consequence of this is that the restaging of the smelting processes is able to resist metaphor, and that the interpretations that arise from documentary evidence of such restagings are even more able to resist

9. The very fact that many would be shocked by my comparison of African conditions with Western social conditions and theories demonstrates the necessity and urgency of a more up-to-date mode of analysis. My justification is in the reasoning that it is unlikely that any culture nowadays can be restricted to what happens within specific spatial limits, especially with the proliferation of diasporas and the globalization of mass media.

10. We know from Derrida that the performative enacts the now of writing in the present time (Shoshana Felman, *The Literary Speech Act: Don Juan with J.L. Austin or Seduction in Two Languages* (New York: Cornell University Press, 1983). Relating this specially to Felman's account of the "scandal of the speaking body" (from Molière's *Don Juan*), then according to Modelski (Tania Modelski, "Some functions of Feminist Criticism, or the Scandal of the Mute Body," *October* 49 (summer), pp. 3-24), the issue at stake is not really about the "speaking body," but really about the "mute body." Modelski maintains that the project of feminist critical writing should be "towards a time when the traditionally mute body, 'the mother' is given same access to 'the names' – language, speech, that have men have enjoyed" (Phelan: 1993, 7).

the metaphoric. This especially makes the position of specialists like Eugenia Herbert on the role of gender power within African iron smelting all the more open to question:

> I have limited myself to activities dominated by males – metallurgy, hunting, and royal vestidure – not simply to keep the subject manageable but to show how a set of beliefs support male appropriation or replication of female procreativity. Thus when one turns to a comparable female activity, pottery, the asymmetry with which these enterprises becomes clear: pottery simply does not invoke the same "power field" even though the procreative paradigms are applicable.[11]

In many ways, considering Herbert's position as a professor of African history, an academic interest in exposing the intricacies of gender and power within paradigms is understandable. While there can be no doubting the disparate power balances between female and male activities in many parts of the world, including Africa, a few points need to be stated. The first being that it is perhaps to the Western eye that pottery does not invoke the same power field as hunting. It is also true that Africa has many queens instead of kings, with many societies considering the role of the queen mother to be even more important that that of the king himself, and finally, that many men produce pottery. Yet what is more evident here is the projection of the metaphor of gender.

Herbert's observation on the role of female procreativity, it could be argued, actually undermines feminine achievement through the projection of the Western hierarchical bias in favor of science over nature, as can be seen notably from Hegel onwards. This doctrinaire equates clay with pottery, craft, and by extension the natural, and quintessentially female (mother nature, etc.); while iron is equated with smelting, industry, and by extension the scientific, the male. This equation holds true despite a hugely underplayed paradox, namely that, as Herbert noted, "ironworking in Africa presents us with an apparent paradox of a male-dominated craft that must invoke elements of female power to succeed." The main concern, however, would seem to be that the presence of the lone female elder, herself an equal in age to the leading smith, precludes the conclusion of any obvious power imbalance based on gender. This situation makes the application of a

11. Eugena W. Herbert, *Iron and Power*, chapter 5.

straightforward feminist gender critique of the power relations within the smithing process all the more difficult. The acquisition of knowledge is preconceived to be largely determined by age and gender, precisely to support presupposed power structures which are not obvious.

In much the same way as the performative aspects of ironmaking in Africa resist the metaphor of gender, Phelan further rejects the paradigm that:
> upholds the vertical hierarchy of value through systematic marking of the positive and the negative. In order to enact this marking, the metaphor of gender presupposes unified bodies are different in "one" aspect of the body, that is to say, difference is located in the genitals.[12]

Perhaps if difference were located in other areas, it would be possible to understand why it is considered necessary to have the lone female elder. In this way we could surpass the obvious associations of the furnace with the female, with the metallic iron as the child, and so on. It also remains true though, as Foucault remarked, that we will always know their cultures (and technologies) better than them, rather like we know that a person is mad, and therefore it is best to avoid talking to them.[13] The reasons why many in Africa stopped the ironworking processes are frequently explored. For example, could it be that the specialists had refined the process to such an extent that there was no need to carry on. In recent years, spanning the period of these reconstructions, it also would have been possible for the smiths to obtain cheap metal from abroad. Or perhaps for the sake of conserving natural resources, they believed that it was best to end the process. Such insights would be a welcome diversion from the numerous researches directed at exposing the unique or superior nature of the African smithing processes.

12. See Phelan: 1993, 7, p. 151. Taken from the conclusion of Herbert's book, where she attempts to defend her authority on the subject. After all, if two of the most promising West African archaeological specialists say that it is African cosmology and not technology that we should be focusing on, then it must justify the need to better understand the sophistication of the processes involved rather that focus on generalizations (Herbert: 1993).

13. Foucault has already analyzed the construction of such a language about madness. It does not take a great mental extension to appreciate that what anthropology actually does is to frame the Other as the madman. See Michel Foucault: *Madness and Civilization* (New York: New American Library, 1965).

The however, question begs to be answered: why this obsessive academic interest in African ironworking? The answer has to be in order to satisfy the curiosity for the exotic. As the anthropology critic Bernard McGrane concisely puts it, to:

> see difference as "only" difference or as merely difference is itself an accomplishment rooted for the most part in the late Enlightenment, when bourgeois good-conscience became troubled and self-conscious with regard to the non-European Other, and insisted, for the sake of good-conscience, that the Other is not-inferior-but-different. The initial formulation of the non-European Other as different, then, was, grounded upon the bourgeois-moralistic denial that he is inferior… and hence, also, superior.[14]

It is particularly alarming that still so much research funding is aimed at ethnographers traveling to other cultures, in order to bring us, in the contemporary sense, evidence of the Other, which convinces us of our difference. In fact difference is now democratically experienced as cultural difference. It may be that some modern ethnographic texts aim to speak well of the Other through political correctness, but the fundamental flaw remains that we never, in good ethnographic practice, speak to the Other.[15] Even when the Other is addressed, it must be on our own terms.

This attitude manifests itself most efficiently in the visual representations of the plight of the Other. To watch almost anything on television about Africa in the West is to experience varying degrees of voyeurism. We are not presented with anything other than a tragic, phenomenological account of disasters and conflicts man-made and natural. It would seem, according to Levinas in *Otherwise than Being,* that our ethics are frequently the optics that sustains the comforting view of Africa as a poor relation to the West. In this matter, it is worth noting that during the recent environmental disaster that befell Mozambique, we are reluctant to acknowledge the direct relationship between the severe atmospheric changes and global (Westernized) industrial pollution. Our guilt towards those in the developing world who suffer from disasters related to such pollutions leaves us in a

14. Bernald McGrane, *Beyond Anthropology, Society and The Other* (New York: Columbia University Press, 1989). In the book Mc Grane deconstructs the systematic construction of the Other from pre-Enlightenment to the twentieth century.
15. See the analysis of the third-person grammatical in the conclusion of McGrane's article (McGrane: 1989); a more detailed account is in Fabian: 1983.

dilemma of how to help. So long as the developed world, and the United States in particular, with a mere 4% of the global population, but responsible for 40% of industrial pollution, continues to defy the terms of the Kyoto Summit[16] on environmental control – with many arguing for leaner cuts in emission levels than rival countries, while insisting that the developing countries also face stiffer cuts, or even be prevented from exploring the financial benefits of industrialization that they continue to enjoy – events such as those in Mozambique will be repeated with more alarming frequency.

In the past, when Africa was viewed as being devoid of technological knowledge, we could confine its representation to the natural. We even now know that the human species originates from Africa even though when Cheikh Anta Diop in Senegal was carrying out the research with the same aims of proving that Africa was the cradle of all civilizations using Carbon 14 techniques, he was met with considerable resistance and scepticism.[17] This scenario is rather more sober than the argument over the correct model for the DNA molecule between the triple-helix structure of Pauling and the double-helix model proposed by Watson and Crick.[18] Once again, it seems that vilifications of everything African would need to pass through the Western laboratory. Or is trying to repay our debt to African technology not perhaps more akin to Levinas's notion of the repayment of the debt that increases with each payment? Is it not even harder to pay off a debt, however complicated, if we do not acknowledge that there is a debt in the first place?

16. The Kyoto Summit on Climate Change, December 1-10, 1997, Kyoto, Japan, see <http://livingplanet.org/climate/kyoto/conference2.htm> and others for further information.

17. See Cheik Anta Diop, *The African Origin of Civilization, Myth Or Reality* (Lawrence Hill Books, ISBN 1-55652-072-7). There are, however, other important works that are published in journals such as the dosage test, a technique developed by Diop to determine the melanin content of the Egyptian mummies. The irony of this new technique was later adopted by the U.S. forensic department to determine the racial identity of badly burnt accident victims. Yet the date they have never acknowledged the author of this test! See the website located at <http://home3.inet.tele.dk/mcamara/antadiop.html> for more details.

18. A classic example illustrating the argument from science: the war for authenticity between Pauling's postulation of the triple-helix structure of the DNA molecule and the opposing double-helix position of Watson and Crick. What happened subsequently defied logic itself. Despite the fact that Pauling's model was the earlier one, once scientists had "pictured" and "identified" the two-strand model (even though they could not have known what they were looking at), this model won the day by "stealing the show" (Menser and Aronowitz: 1996, 11-12).

The Cover Story: The ironmaking tradition of the Haya people of northwest Tanzania is more than 2,200 years old. Metallurgical analysis now shows that Haya iron is distinct from that produced by Early Iron Age bloomery furnaces in Europe, a technology long thought to have arisen from the same source. Although they no longer practice iron smelting, some Haya remember the techniques and, by building furnaces such as the one seen here under construction, have helped scientists explore how the distinctive iron chemistry arises. Peter R. Schmidt and S. Terry Childs review these studies in *American Scientist*, November-December 1995, pages 524-533. (Photograph by Winnie Lambrecht.)

American Scientist

NOVEMBER–DECEMBER 1995 — THE MAGAZINE OF SIGMA XI, THE SCIENTIFIC RESEARCH SOCIETY

Sequence of steps in a Haya smelt produces unusual iron chemistry. Iron ore is roasted with wood before the smelt (1), removing moisture, increasing the surface area of reaction and partially reducing (removing oxygen from) the ore. Over a bowl lined with termite earth was built a shaft that would be supplied air by tuyères, or blowpipes, extending deep into the furnace (2). The preheating of air in the tuyères allowed the furnace to achieve higher temperatures while maintaining a reducing environment. During smelting (3) the charge of ore and charcoal was added from the top. Contact between the slag that formed as the ore melted and the carbon-rich bed of charred reeds caused a carbon boil, a violent reaction of oxygen and carbon, further reducing the slag and causing iron crystals to precipitate in an iron bloom (4) that was removed at the end of the smelt. (Additional ore pockets were roasted in the furnace for future use.) The local trees and grasses used as fuels gave Haya iron, past and present, high phosphorus content.

Early Iron Age bloomeries in Europe shared some characteristics with the Haya furnaces. A bed of charcoal, along with charcoal added in a mixed or layered charge with iron ore, fueled the furnace. A tuyère, shallowly inserted, supplied air to maintain a fire, and below the tuyère formed a layer of liquid slag and a bloom made up of iron with silicates and bits of unreduced ore. (*American Scientist*, November-December 1995, 83:524-533.)

Oladélé Ajiboyé Bamgboyé

Unmasking III

Background to the Ideas

This project centers on questions of boundaries, and more specifically the issues of accessibility within certain boundaries that have come to be so important in recent artistic, philosophical and cultural thought. Along with issues of accessibility and boundaries, comes the inevitable issues of positioning, viewpoint and perspective of both the artist as well as the audience, or more appropriate in this work, the participants.

How to best demonstrate and critique the issues of the culture of technology, and challenge the overt Western bias of most theorem that almost inevitably place Africa in the realm of the ever-beautiful, natural and ahistorical construct has been a major project for the artist in the past few years. In deciding to side-step issues of authenticity, originary truth, and romanticization, the artist has made a bold statement by deciding to showcase apparently archaic monumental objects that are frequently endowed with an unquestionable air of reality, in the digital 3-dimensional computer graphics-driven Internet realm.

This abstraction of a real object from life into mathematical syntax is common within computer programming language and digital simulation. When the participants in the project are further empowered through the possibility of being able to manipulate in real-time an object that many of them may never have access to, with the possibility of customizing its appearance; it is the authority to maintain sole access of the object by any one entity that is being challenged rather than the commodification of a rare *objet d'art*.

In the installation *Unmasking II*, shown at ArtPace, San Antonio, Texas, 1999 – the result of working with programmers and 3-d specialists – the artist has embarked on a journey that in the end hopes to be able to deliver fully customized object-variants based on the more famous examples that lie frozen and dormant in the increasingly complex protection of the major museums, in the guise of Virtual Tours that actually eliminate the need for an object in the first place. This particular work, *Unmasking III*, is centered on one particular object held in the Museum of Liverpool in England, whose importance is highlighted in the Museum's Web site:

The Queen Mother Head, Benin, Nigeria, West Africa, late 15th to early 16th century AD. The Benin Bronzes are an important part of the collections of Liverpool Museum and provide a wealth of fascinating information on the history of Benin City. A special way of casting bronzes known as the lost wax method was brought to Benin around A.D.1400 from the Yoruba religious centers of Ife where the method had been practiced for at least 200 years. This bronze head of a Queen Mother is one of the best examples of its type in the world.[1]

It is clear that as well as the object being of a special aesthetic caliber the same can be said of the technology that forged it is also noteworthy. The problem that the project aims to address is that of the continuing construct of a technologically challenged Africa, as the natural, subordinate alternative of the West. To this day, watching most imagery from Africa presents us with a catalogue of natural and manmade disasters, in an environment that seems to be dominated by nature. While the people of Africa may suffer, the construct of it as a natural haven is seen to be of paramount importance to the West.[2]

How these views are changing with greater awareness of the importance of cultural critique of technology, which is of interest in some of the artist's writing, there has also been some "new" evidence brought up by research in the field of archaeology. This has been the subject of much recent research, notably by Peter Schmidt. What is important to realize about this technology is that recent research continues to disprove the commonly held view that African Iron Smelting (which is necessary in the process of bronze smiting), originated from Europe, in a region that is now known as Turkey.[3]

What is wrong with these changes at present? The central problem remains with the theories of cultural critique in that the models of identities based on the binary oppositions of the self/other and center/periphery do not hold much ground in the current climate of fragmentation. An even bigger problem seems to be that, as will all negative-critical projects, cultural theory suffers from the problems of simultaneously borrowing on the language of its "oppressor" (self), whilst trying to use that very language to champion the "oppressed" (other). As such the discourse then continues to

1. See the website located at, <http://www.nmgm.org.uk/nmgm/collectionsframeset.html> for more details.
2. See the article in *documenta X – short guide/kurzführer*, pp. 28-29, one image, artist statement, Cantz, Germany.
3. See <http://www.amsci.org/amsci/articles/95articles/PSchmidt.html> for more details.

be centered around the "self" and as such do not contribute significantly into the necessary project of understanding better the "other." This condition holds for, in varying degrees, the vast majority of cultural theories that are based on the problematic notions of the self/other binary relationship, including those of the "hybrid" self/other.

How does this project address these issues? In the context of *Unmasking III*, the relevance of this is that it is then possible to promote a seemingly "progressive" view of African technology, but maintain a somewhat distant, mystical, performative view of it, as is characterized by the numerous research into the nature of African Iron Technology.

The project situates the technology where it belongs, and more importantly through the demonstration of well-known objects that are only seemingly appreciated solely for their aesthetic and therefore "mystical," "unexplainable," "exotic," "natural" qualities rather than the more rational qualities like those of production and technology.

This view is not intended to set up the traditional binary opposition of nature/technology, but rather to attempt to interject the notion of process into the general appraisal of such objects.

Why is this necessary? This is desirable in many ways, the most pertinent being that of the need to visibly and practically break down the dominant ethic of fixating Africa as devoid of progress, and even ahistorical. This well established tradition dating from Hegel and the Enlightenment continues to be applied at a psychological level to many things Out of Africa. While the challenging of this rigid positioning has been routine in critical post-colonial critique for many years, the aim of the artist is to shift the focus onto more accessible issues of contemporary importance such as the accessibility to cultural artefacts.

Recently, on a visit to Greece, President Clinton was asked to press for the return of ancient Greek artefacts when he visited the British Prime Minister Blair, raising the issues of accountability once more. In respect of African, Oceanic and Asiatic artefacts, the issues are even more pressing. With many museums embarking on the virtual reality experience of their collections, a critical response is necessary. If not there is a possibility that the issues of accessibility to these objects that have been the cause of much friction in the past will be forgotten. I belief that the proper critical response to the virtualization of the museum is to use the technology of today to literally allow the users irrespective of their location to be able to access, manipu-

late, copy and even possess for a small fee these objects that have been denied them for so long.

The approach of this project if we are able to demonstrate, that the modes of production, using advanced technology of the day have always been important, then we can better appreciate why the makers of objects such as the one like the Queen Mother Head have become influenced by the progress in technology and social adaptation. This project takes the view that culture is an evolving entity, shaped and influenced by the society that it resides and vice-versa.

This viewpoint then enables the consideration of modern variants of the Queen Mother Heads, as having a legacy that is linked into those of the perceived "original" object that invariably now resides outside of those cultures that originally produced it. The issue here is not one centered on the quality of the objects in question themselves, but more rather one of diffusing what Brian Massumi has entitled the: "Baudrillard framework" that is all pervasive and one that is the:

> result of a nostalgia for the old reality so intense that it has a deformed his vision of everything outside of it. He cannot clearly see that all the things he says have crumbled were simulacra all along: simulacra produced by analyzable procedures of simulation that were as real as real, or actually realer than the real, because they carried the real back to its principle of production and in so doing prepared their own rebirth in a new regime of simulation.[4]

While the application of the Baudrillard framework is accepted within the limits of the production of the meaning of contemporary culture within Western hyperrealist domain, the extension of these concepts to the cultural productions outside of the West, in order to better understand them, is non-existent. The general consensus is that simulacra are somehow best confined to the West, ensuring that the challenge to the burden of representation within art and culture is consequentially confined to the Westernized cultures.

4. Brian Massumi, from REALER THAN THE REAL The Simulacrum According to Deleuze and Guattari, as posted on the <http://www.anu.edu.au/HRC/first_and_last/works/realer.htm> on 8/22/99, originally published in Copyright no.1, 1987.

5. Ibid, see also Gilles Deleuze and Félix Guattari, Mille Plateaux, Minuit, Paris, 1980, translated to English under the title A Thousand Plateaus, by Brian Massumi, University of Minnesota Press, 1987.

What such a strategy achieves is that of conditioning that the objects that are Western continue to explore what Massumi has called a "logic capable of grasping Baudrillard's failing world of representation as an effective illusion the demise of which opens a glimmer of possibility."[5] Other objects continue to be limited to by the binary opposition of the fake copy/the model and representation/indetermination, in other words, the mode of analyzing such extra-Western objects will continue to be subjected to the Baudrillard ideas.

This could well explain our disgust of the development of mass production techniques of cultural objects from these cultures, which led to the genres of Tourist Art and Airport Art. Yet I am not interested here in determining which classes of objects are superior or even desirable to the other. Rather, I aim to challenge the apparent consensus that continue to confine the best efforts of certain non-Western cultures to singular "masterpieces" of a bygone era.

How will this be done? By showcasing various "qualities" of the same class of object, in this example the bronze Queen Mother Head of which various examples are included in the image appendix, drawing attention to the multiplicities of Queen Mother Heads, and challenging the superiority of one over the other. This approach is taken in the aim of questioning and surmounting the problematic of accessibility in the wake of cultural fragmentation through the use of technological advances in communications technology. Compare three variants of the Benin Queen Mother Heads from three famous collections.

The Head that resides in the Museum of Liverpool will be used as the model on which the image manipulation will be based, since it is the most accessible within the realms of this project. This means that the following situation will be set up, to enable the web-user to be able to download, manipulate and save various versions of the head. Another factor in this decision is that from the museum website, it is apparent that there is considerable desire to enable the head itself to be more accessible to users who may never visit the museum, from the website located at <http://www.nmgm.org.uk/top10/treasure.html#> the set-up moves beyond the limitation of the Museum's existing OpenPix technology.

The process of digitization that occurs is intended to have the following impact on the delivered imagery:

Three AXIS Web-Server 2100 Cameras "watch" the head in its present location, thereby providing a LIVE FEED of the head to the web every 2-5 seconds directly from the Museum. The image from the AXIS camera is sent to the web server as a compressed JPEG file, which is decidable by all web browsers. The WEBSERVER has a specially produced JAVA, C++ or similar image manipulation program/script that can randomize the appearance of the object, in real-time, examples of this includes the interaction of especially composed JAVA APPLETS. The image is delivered to the user using Director Shockwave, since in this format, it is possible to generate TEXTUREMAPS for the image, in conjunction with the WEBSERVER, and this allows the element of customization and interactivity for the end user. The resulting new images can be saved into an image database, which can be used as the basis for the generation of the TEXTUREMAPS.

In particular, I am interested in employing the current distance/geographical foreshortening qualities of the Internet Technologies as a tactic to combat enforced fragmentation. It is a central aim to potentially enable Internet users in Benin City, Nigeria the opportunity to interact in "real-time" with the objects that are held in collections that are geographically out of their reach.

Biography

Oladélé Ajiboyé Bamgboyé

is an artist living and working in London. Born in Nigeria (1963), he grew up and studied Chemical and Process Engineering in Glasgow, Scotland and Media and Fine Arts in London. He has held solo shows in Scotland, Estonia and Germany, and has taken part in major exhibitions including *documenta X*, Kassel, *2nd Johannesburg Biennale*, Johannesburg, South Africa, *In/Sight, African Photographers 1940 – Present* at the Solomon R. Guggenheim Museum, New York, and *Inclusion/Exclusion, Art in the Age of post-colonialism and Global Migration* at the Reininghaus and Künstlerhaus, Graz, Austria. Winner of several awards, including grants of the Scottish and British Art Councils as well as the Gulbenkian Foundation New Horizon Bursary to develop new ideas in film making. Currently, he divides his time between exhibition curating; writing on culture, and on the pitfalls of the increasing employment of a quasi-anthropological framework within curatorial practice; as well as developing complex interactive installations using computer programming.

Editors
Oladélé Ajiboyé Bamgboyé
Bartomeu Marí

Copy editor
Brian Holmes

Coordination and production
Monique Verhulst

Design
Gracia Lebbink

Typesetting
Holger Schoorl

Printed by
Snoeck-Ducaju & Zoon, Ghent, Belgium

All rights reserved.
No part of this book may be reproduced in any form by any electronic or mechanical means (including photocopying, recording, or information storage and retrieval) without permission in writing from the author and the publisher.

© 2000 Witte de With and the author
ISBN 90-73362-47-4

Acknowledgments
The text *What is in a Print?* was written in 1998 as MA (Media) Report, Slade College of Fine Art, University College, London.
The cover of *American Scientist* is used by permission of *American Scientist*, magazine of Sigma Xi, The Scientific research Society and the photographer Winnie Lambrecht.

The exhibition of work by Oladélé Ajiboyé Bamgboyé has taken place at Witte de With from April 28 to June 25, 2000 and will be documented in From #3 (Fall/Winter 2000).

Witte de With, center for contemporary art
Witte de Withstraat 50
3012 BR Rotterdam
The Netherlands
tel. +31 (0)10 41 10 144
fax. +31 (0)10 41 17 924
e-mail info@wdw.nl
website www.wdw.nl

Staff
Director: Bartomeu Marí; Deputy director: Paul van Gennip; Exhibitions: Tanja Elstgeest, Nathalie Zonnenberg; Theory & Communications: Valentijn Byvanck; Publications: Monique Verhulst; Education & Internet: Ariadne Urlus; Secretarial office: Carolien Ruigrok (office manager), Yvonne van de Griendt, Mariëtte Maaskant; Technical staff: Gé Beckman, Line Kramer; Reception: Maaike Drescher, Terry van Druten, Belinda Hak.

Witte de With is an initiative of the Rotterdam Arts Council and is supported by the City of Rotterdam and the Dutch Ministry of Culture.

Distribution International: Idea Books
Nieuwe Herengracht 11, 1011 RK Amsterdam,
The Netherlands
Phone +31 20 6226154, Fax +31 20 6209299

Distribution in England: Cornerhouse
70 Oxford Street, Manchester M1 5NH, England
Phone: +44 161 2001503, Fax +44 161 2001504

Distribution in the US: D.A.P.
Distributed Art Publishers Inc.
155 Sixth Avenue, 2nd Floor, New York, NY 10013, USA
Phone: +1 212 6271999, Fax: +1 212 6279484